HOW TO LOOK AT MODERN ART
N 6490 Y46 1991

DATE DUE

NO 20 '92		
MR 12 '93		
MY 28 '93		
NO 10 '94		
NO 28 '94		
JE 1 '95		
JE 15 '95		
NO 20 '96		
DE 4 '96 AP 7 '97		
DE 3 '97		
NO 15 '99		
DC 30 '00		
AP 20 '02		
DE 3 '02		
NO 15 '05		

The true artist helps the world by revealing mystic truths

not have a name as such. The task was not relegated to a uniquely informal group within the culture. Perhaps, therefore, there is some wisdom in reclaiming our right to have a say in what art is in our own time. Art is too important for us to stand outside the decision-making. We might treat art experts in the same way that we consult, respect, and listen to doctors. We know that their training, years of experience, intelligence, and insight—as well as all the diagnostic tools they have—give us a great deal of useful information. But still we tend to

Previous page:

BRUCE NAUMAN (American, b. 1941)
Window or Wall Sign. 1967
Blue and peach neon tubing, 59 × 33″ (149.9 × 83.8 cm)
Courtesy of Leo Castelli Gallery

Using neon to create an art object that is also, appropriately, a sign, Bruce Nauman counts on neon's glow to create an aura around his perhaps ironic, nonetheless profound, statement about "true art." His organizing principle is the spiral, a form that has the property of seeming infinite and also suggesting opposing connotations, such as plodding snails and dangerous whirlpools. Blue and red are primary colors that here combine as light to create a purple glow. By using light, Nauman allows us to think of the Impressionists, who were focused on the fleeting properties of light in nature. We might also think of Georges Seurat, whose colors were established separately and then mixed in our vision. Nauman's use of an advertising medium (often associated with exaggeration) designed to attract people to a product or place forces us to question the seriousness of Nauman's truism. We can also look on it as a play on words: Does only the "true" artist, not the false one, reveal "truths"?

consult with more than one if a problem is serious or if the solution suggested seems drastic. We also demand that they speak to us in plain language and respect our curiosity, right to know, and desire to exercise some authority over our own lives. Furthermore, some of us also think, from time to time, that science is great but so are grandma's tea remedies or, more seriously, notions of "wellness" that have to do with diet, the effects of stress and negative emotion, and so forth.

My analogy here is intended to say that, while we should respect artistic authority, we need not rely simply on one opinion. We can challenge authority by asking questions, querying assumptions, and identifying biases. We can ask that those who might want to impose their opinions—or their public sculpture—on us defend themselves in terms and in forms we can easily follow. We can also trust ourselves to have useful, definitive insights, if—and maybe only if—we have bothered to look at and think seriously about what artists produce. Even if we want to bypass questions of ultimate quality, there is still a job to do in figuring out what the art means to us, personally.

For those who want to participate actively in debates on what makes a work "good," we need to create some parameters by which to measure artistic success. My own fairly simple guideline is as follows: Art is a human-created expression that makes me think and feel at the same time. The thoughts and emotions it provokes are either new or different from the way I considered them before; they may tap into something I only suspected or maybe did not know that I knew. Most important (and this is how I ultimately decide merit for myself), good art sustains my interest over time, perhaps for its original appeal, perhaps for reasons that are new each time I see it.

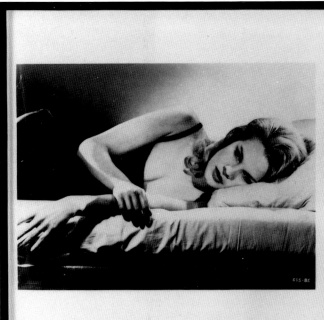

Had I been wrong to let them do it? The doctor had in no way talked me into becoming an excitingly beautiful woman. He had simply given me a choice: to return to the personality the trauma had obliterated in a grinding crash of metal and glass, or to create an entirely different one...one as lovely as I liked. In making me a new woman he had created an image that was exquisite. But I wasn't sure, now, that I could...or wanted to be... the sort of person the image suggested.

RENÉ SANTOS (American, b. Puerto Rico, 1954–1986)
Untitled. 1979
Black-and-white photograph, 25 × 40″ (63.5 × 101.6 cm)
Private Collection

A student of culture, high and low, and an astute observer of the way in which images, texts, and context either support or contradict each other, René Santos incorporates actual black-and-white movie stills (this one depicting Carroll Baker in *Baby Doll*) with texts that he wrote imitating the style of cheap novels. The interaction between the image (which we might recognize) and the odd narrative is funny, cryptic, and touching. That it is to some degree ironic is suggested by the artist's own androgynous name and his use of first person in the text. Are we supposed to think the image illustrates the text, or is this autobiographical? Is all art, somehow, about oneself, despite efforts otherwise? By calling the work "Untitled," Santos refers to a naming device used when an artist either does not wish to give a verbal key to meaning or perhaps does not want to encourage interpretive activity on the viewer's part. Santos might be suggesting, on the one hand, that we remain content with superficial information while, on the other hand, his storytelling qualities urge us to look for more.

USEFUL VOCABULARY

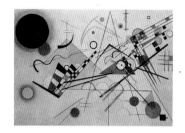

VASILY KANDINSKY (Russian, 1866–1944)
Composition 8, no. 260. 1923
Oil on canvas, 55½ × 79⅛″ (141 × 201 cm)
The Solomon R. Guggenheim Museum, New York. Gift of Solomon R. Guggenheim, 1937

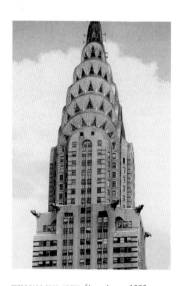

WILLIAM VAN ALEN (American, 1882–1954)
Chrysler Building, New York. 1930

Abstract Expressionism

This term refers to nonrepresentational art of the mid-twentieth century in which line, color, and technique combine to express and/or elicit powerful emotion. Sometimes called the "New York School," Abstract Expressionism ranges from impeccable geometry to "Action Painting," the latter exhibiting the energetic imprint of the working process (or gesture) visible in such details as brushstrokes. It is stylistically varied but usually marked by a tendency to exploit the expressive possibilities in colors and materials. Franz Kline's powerful black-and-white paintings (p. 37), with their sweeping brushstrokes, summarize the more action-oriented aspects of Abstract Expressionism. The work of Barnett Newman (p. 87) reflects the more geometric approach.

Abstraction

Even when it appears to be trying to re-create reality, all painted imagery may be seen as an abstracted representation of the physical world, and therefore most art is to some degree abstract. In modern art, abstraction has become a thing in itself, often by way of systems that simplify or try to rationalize what we see in reality. The term is most often applied to art that contains no recognizable imagery and uses pictorial and sculptural languages only (color, line, shape, form, texture) in order to create its own reality—separate from any other source—sometimes referred to as nonfigurative, nonobjective, or nonrepresentational (each implying slightly different things). Two illustrations by Kandinsky represent the major strains in modern abstraction, one based on geometry (left) and the other organic or lyrical (p. 55).

Art Deco

This style in architecture, and particularly the decorative arts and industrial design, flourished in the 1920s and 1930s. Although stylistically related to Art Nouveau, its greatest influence, Art Deco is based on geometric rather than organic forms. Its forms and themes often seem to characterize enthusiasm for the machine age, as in the architecture and sculpture of New York City's Rockefeller Center and the Chrysler Building.

Art Nouveau

A style of decorative art that thrived from the 1880s until World War I, Art Nouveau is characterized by asymmetrical designs and rich patterns of curving lines, usually derived from a variety of organic forms, ranging from flowers and other plants to the hair and bodies of female figures.

The Bauhaus

This school of art, architecture, and functional design was founded in Weimar, Germany, in 1914; its faculty and students included many of the most

influential artists of the century. Best known as the place that gave credence to architect Louis Sullivan's famous dictum, "Form ever follows function," the school emphasized the synthesis of the two in the creation of useful structures and objects, hoping also to express social ideals that were apparent in economy of lines and materials. The Bauhaus aesthetic rejected past styles, especially ones involving unnecessary ornamentation, in order to embrace the potential of the modern world. Bauhaus influence on architecture in terms of style, more than the content of its ideals, can be seen anywhere in the world today, particularly in glass and steel skyscrapers, whose simple lines depend on materials and proportions for aesthetic appeal.

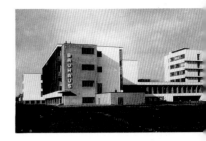

WALTER GROPIUS (German, 1883–1963)
View of Bauhaus Building, Dessau,
Germany. 1925–26

Color Field Painting

This style of abstraction emphasizes color, and is often painted on so large a scale that color fills the viewer's entire field of vision. At issue to these painters, including Helen Frankenthaler (p. 87), are flatness and the bonding of paint and canvas to become a single integrated unit instead of canvas simply being the ground on which paint is applied. This emphasis is an aspect of one of modern art's tenets that art should not be about something else but instead should express its own specific and unique qualities, independent of representations of reality or illustrations of an ideology.

Conceptualism

Using visual means not for their aesthetic qualities but to communicate ideas or examine theoretical problems, Conceptual artists often bypass traditional materials or elements of art, relying instead on words, photographs, and/or artifacts. The ideas conveyed often refer to visual matters, as in suggesting a point of view or a variety of ways of looking at something, for example, a chair.

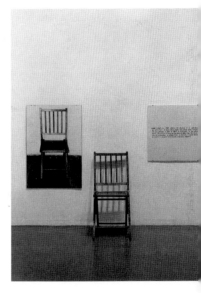

Constructivism and Suprematism

These styles in Russian art were developed at the time of the Bolshevik revolution in order to give visual form to revolutionary ideals. Both are types of abstraction based entirely on geometry because of its pure simplicity, yet with the ability, like some poetry, to suggest much with little. Often using industrial materials, Constructivism, in particular, sought to embody the postindustrial era and to create a vocabulary of spatial relations equally useful in design, architecture, painting, and sculpture, one that could be "constructed" by anyone, thus ensuring a day-to-day reality for artistic expression. Suprematism is clearly illustrated by the works of Kasimir Malevich (pp. 43, 56).

JOSEPH KOSUTH (American, b. 1945)
One and Three Chairs. 1965
Wooden folding chair, photograph of
chair, and photographic enlargement
of dictionary definition of chair;
chair 32⅜ × 14⅞ × 20⅞″
(82 × 37.8 × 53 cm); photo panel
36 × 24⅛″ (91.5 × 61.1 cm); text
panel, 24 × 24⅛″ (61 × 61.3 cm)
Courtesy of Leo Castelli Gallery

Cubism

Perhaps the single most influential style of the twentieth century, Cubism was formulated by Picasso and Georges Braque between 1907 and 1914. Cubist art

abandons or transforms traditional notions of perspective, modeling, and placement, replacing them with a less representational analysis of a subject. Cubists sought to depict an intellectual and abstract reality. People, places, and things are reorganized by an intuitive system that has affected later artists profoundly because of its tendency toward geometric simplification, violation of spatial expectations, and its breaking down of the systems of illusionism. (See p. 110 for Picasso's painting entitled *Girl with a Mandolin [Fanny Tellier].*)

Dada

French for "hobbyhorse," this term was randomly picked from a dictionary by a group of artists to reflect their attitude, which was blatantly and purposefully "anti-art." This anarchic movement began in Zurich in 1916, born in disillusionment in part because of World War I. Given various casts, from highly political in Berlin to more playfully conceptual in Zurich, the movement soon spread to major cities in Europe and to New York. Dada reacted to virtually all art traditions, especially in its emphasis on memorabilia as its principal expressive medium. The Dadaists intended to shock people through treating everyday objects (readymades) as if they were art, using nonsensical writing instead of paint as a major means of expression; creating ephemeral works, such as performances, instead of making permanent monuments; and emphasizing irrationality instead of trying to find order in the chaos of twentieth-century politics, economics, and warfare. Ideas, said the Parisian Dadaists in particular, were the essence of creativity, not craft, as they elevated actions over objects. Dada represents a major step in redefining art and its functions, helping to initiate one of the cultural preoccupations of this century. (See Meret Oppenheim's *Object,* p. 91.)

Deconstructionism

There exists a tendency in recent art to subvert or pull apart and examine conventions of existing modes of expression. If, therefore, originality was a tenet of modernism—each artist having his or her own characteristic and unique style—Post-Modern work tends to minimize individual distinctions, appropriating and incorporating all manner of existing images, thereby "deconstructing" the notion that it is possible or necessary to invent an individual signature that has no precedent, no equal. (See the discussion of the work of Sherrie Levine, pp. 123–28.)

De Stijl

This Dutch term that translates as "the style" was coined by several artists (principally Piet Mondrian and Theo van Doesburg, see pp. 39 and 44) to emphasize their commitment to the absolute correctness of a particular mode of expression, characterized by a limited use of color (only the primaries plus

black and white) and a concentration on balancing these colors within a structure of lines and rectangles to achieve a perfect harmony.

Fauvism

This French term (referring to "wild beasts") originally was applied pejoratively by a critic to the aggressively colorful work of a group of young artists in the first decade of the twentieth century. Fauvist art is representational and characterized by the use of greatly exaggerated color as the dominant element in painting, often applied with little logic as to subject, perhaps to emphasize the essence rather than the appearance of things. The bright color of this early painting by Henri Matisse — *Girl Reading (La Lecture)* — demonstrates the visual excitement of Fauvism.

Futurism

Futurism developed in Italy at roughly the same time as Russian Constructivism. Its practitioners were equally determined to find an expression suited to the times but focused more on the energy and brute force of the mechanized age. Futurism is recognizable by its frenetic quality, its use of exaggerated color, and particularly the repetition of lines that create the sense of rapid motion, emphasizing the speed and dynamism of the modern era. Like other styles of the time, it sought expression through a variety of arts, including manifestos and prose. Although Futurists frequently depicted machines at work, Umberto Boccioni incorporated the typical Futurist style in his *Dynamism of a Soccer Player* (p. 19).

German Expressionism and Expressionism

Shortly before World War I, certain German artists, including Ernst Ludwig Kirchner and Emil Nolde, capitalized on strong color contrasts, vivid imagery, and angular, simplified forms, crudely rendered, to depict the emotional and psychological concerns of themselves or their subjects. They were often expressing their own hostile and angry stances, especially toward "bourgeois" values or vulgarity and moral decay (see Kirchner's *Street, Dresden,* p. 51). One group of German Expressionists sought to explore visual elements (color, line, subject) for more spiritual or mystical properties, creating gentler but still vivid images, often depicting mythic aspects of nature.

The desire for emotionally charged painting also fueled the Abstract Expressionists, and it continues to be a primary motivation in current art. Today, the term *Expressionism* refers to this tradition of emphasizing the emotional content of art. Usually, this content emerges from emphatic, dramatic color and line, as well as from the visible presence of the artist's gesture in making the work, and often from the choice of subject, which can range from religious fervor to anxiety about city life, war, or death.

HENRI MATISSE (French, 1869–1954)
Girl Reading (La Lecture). 1905–6
Oil on canvas, 29⅝ × 23⅜" (75.2 × 59.4 cm)
Private Collection

CLAUDE MONET (French, 1840–1926)
Banks of the Seine, Vétheuil. 1880
Oil on canvas, 28⅞ × 39⅝"
 (73.4 × 100.5 cm)
National Gallery of Art, Washington.
 Chester Dale Collection

JUDY PFAFF (American, b. England, 1946)
3-D. 1983
Installation
Courtesy of Holly Solomon Gallery, New
 York

Impressionism

The Impressionists challenged academic traditions in French painting in the 1870s and 1880s, particularly. Impressionism had tremendous, widespread influence because of its technical innovations as well as its desire to depict reality through capturing ever-changing aspects of light as the phenomenon that makes vision possible. Claude Monet was the classic practitioner of this style, which is characterized by beautiful, strong colors, broad visible brushstrokes, outdoor subjects, including people at leisure, and a light, airy appearance.

Installation

This form of sculpture usually is made for one specific site and is often temporary, designed to either enhance or enliven the chosen space. Sometimes installations significantly alter the space they occupy and at other times might be designed to elicit greater awareness of existing visual qualities or the history or function of a particular space. Judy Pfaff's approach colorfully animates spaces, essentially turning them into three-dimensional drawings.

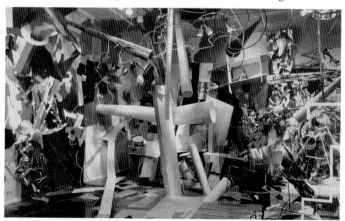

Minimalism

Minimalist art reduces visual content to the simplest of geometric shapes and forms, seeking to eliminate all possible expressive information, including any evidence of the artist's hand at work. The work is often very large and uses industrial fabrication techniques and materials, sometimes left unfinished, sometimes carefully tooled. It is most often monochromatic. A singular design principle, such as a grid or cube, will usually dominate, and such elements are often repeated with little or no variation, sometimes many times. The stripping away of all but the essence of a shape, scale, or material allows for a very concentrated, pure, and quiet experience, somewhat like a meditation. (See Sol LeWitt, pp. 12–13.)

Modernism

The term was first applied to a time period, beginning in the 1880s, when certain artists began to build on Impressionism's radical steps away from tradition in order to be deliberately different, critical, and often dissenting from the dominant taste of official salons and their strictures on styles, techniques, materials, and subjects of art. More recently, it has been applied to a variety of mostly abstract styles, which are often idealistic and individualistic. Modernism strives toward originality, trying to shake loose influences of the past. It is strongly dependent on the formal vocabularies of art (line, color, shape, form) and the inherent properties of materials. Its most infamous manifestations are either geometric and/or expressive and can be exemplified by such pure, bold, and powerful statements as the steel and glass skyscraper and the action-filled paintings of Jackson Pollock (pp. 114–16).

"Neo"

This prefix meaning "new," when affixed to another "ism," theoretically describes a later manifestation or reintroduction of a style—as in "Neo-Expressionism," used in the 1980s to describe the work of such artists as Eric Fischl (p. 142).

Op Art

This abbreviation of "optical art" refers to a specific style in which geometric forms are employed to create dynamic visual effects. A 1960s phenomenon, its starting points are color theory and optical illusions, the latter commonly found in texts dealing with perceptual psychology and typical of so-called psychedelic imagery. Op Art is itself a serious exploration into the ways that color, line, and space interact with the eye in a lively manner, as one can easily see in the paintings of Bridget Riley.

Outsider Art

Outsider Art is characterized by highly individualistic, even quirky, artistic expression with little or no reference to established artistic conventions. Its practitioners, such as Howard Finster, are often untrained and are usually people who inhabit the fringes of society—certainly outside the mainstream— in institutions, perhaps homeless or reclusive, or otherwise isolated by choice or force from the general population. French artist Jean Dubuffet coined the expression *Art Brut* (Raw Art) to describe such material and acknowledged its profound influence on his own style and that of many others.

Pattern Painting

Prominent in the 1970s, Pattern Painting focused on and elaborated tendencies in certain art (Islamic, for example) toward strong and lively expressions of geometric or nature-inspired motifs. Henri Matisse is a major influence on such

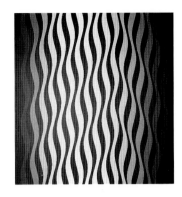

BRIDGET RILEY (British, b. 1931)
Drift 2. 1966
Acrylic on canvas, 91½ × 89½"
 (232.4 × 227.3 cm)
Albright-Knox Art Gallery, Buffalo, New
 York. Gift of Seymour K. Knox, 1967

HOWARD FINSTER (American, b. 1916)
*President Roosevelt, The Wise Man of
 His Days*. 1983
Enamel on wood, 11½ × 9¼ × 3½"
 (29.2 × 23.5 × 8.9 cm)
Courtesy of Phyllis Kind Gallery

ROBERT KUSHNER (American, b. 1949)
Homage to Dufy. 1980
Acrylic on canvas, 8′1″ × 11′10″
(246.4 × 360.7 cm)
Private Collection, courtesy of Holly
Solomon Gallery, New York

JOHN KELLY (American, b. 1954)
Find My Way Home. 1988
Performance, Dance Theater Workshop,
New York City

RICHARD ESTES (American, b. 1936)
Ansonia. 1977
Oil on canvas, 40 × 60″ (101.6 ×
152.4 cm)
Whitney Museum of American Art,
New York

art because of his emphasis on color and harmony and his contentment with joy-filled decoration over more emotionally or psychologically penetrating expressions. Robert Kushner's sensual nudes set within highly decorative environments exemplify this refreshingly beautiful movement.

Performance Art

This basically theatrical, live-performance medium overlays aspects of sculptural installations, projections, movement, sound/music, and/or spoken poetry, with or without a narrative structure. Because of its strong visual presentation and experimental nature, performance art defies any strict categorization except that, like other performing arts, it often happens as a scheduled event, presented before a live audience. Because the performance is transitory, documentation by film or video, photography, and drawings is stressed, as in this photograph of a work by performance artist John Kelly.

Photorealism

A hyperrealistic style of painting derived from photography, Photorealism calls for exact replication of photographic detail. These realists, such as Richard Estes, usually paint from photographs, often snapshots, and emphasize the aesthetics of photographic framing (repeating exactly what is included in the image), limited focus, and particular color tonalities. They also tend to share with photography a focus on the commonplace, often emphasizing a certain banality in both subject and treatment. This style relates to other attempts, such as "superrealism," to use new materials, techniques, and virtuoso craftsmanship to produce art that completely fools the eye in its accuracy at re-creating physical reality.

Pointillism

In this painting technique (also called "Divisionism" and sometimes "Neo-Impressionism") developed by French Post-Impressionist painter Georges Seurat (see p. 59) in the late 1880s, subjects are rendered through painted dots or points of pure color individually applied to a canvas. When viewed from a suitable distance, the colors blend, thus creating the illusion of other colors. The blending in the eye of the viewer also molds forms, light, and shadow.

Pop Art

A movement with its roots in the late 1950s, Pop Art has endured and proliferated since. Most obviously, it incorporates the imagery and/or media of popular culture, usually manipulating them to some degree. These appropriations examine the look, content, and effect of "pop culture," including package design, celebrity watching, and advertising. They also question the values and communication system of "high culture" by juxtaposing it with "pop" mediums: Honed by television, soup-can displays,

and billboards, Pop Art asks, How do our eyes and minds see art? Pop Art, as exemplified in the work of Roy Lichtenstein (pp. 50, 90), provides both accessible imagery and serious intellectual challenge in the questions it raises.

Post-Impressionism

Whenever the art world employs the prefix *post,* it signals an era that is pluralistic and that defies easy labeling, preceded by one that can be seen coherently. This inexact term describes disparate responses to earlier work, some extending its discoveries, some reacting against it.

Some "Post-Impressionist" artists, such as Georges Seurat, tried to give Impressionism a theoretical backbone and rational structure to the instinctual impressions of nature captured by Monet and his colleagues. Others, such as Vincent van Gogh, experimented with color and technique, emphasizing their roles in the expressive content of painting. Still others, notably Paul Cézanne, tried to realign Impressionism's independence with more traditional ways of structuring pictures, pushing toward definitions of painting that were more about how to make pictures than about depicting subjects. Most were freed from any constraints regarding subject matter and, like Paul Gauguin, Odilon Redon, and the Symbolists, could explore diverse worlds of feeling and spirit. Each of these avenues led, in turn, to other twentieth-century developments.

Post-Modernism

This term is used to reflect the diversity of styles and mediums that proliferated beginning in the 1970s, mostly reactive to modernism, ushered in by Pop Art and Minimalism. The existence of reactions to modernism of course does not mean that all modernism ended but rather that the apparently narrow mainstream widened into a more complex, delta-like matrix of styles, attitudes, and sources. Given that what is loosely termed "Post-Modern" is reactive, it is usefully defined by a set of contrasts. Where modernism was seen as elemental and formal, Post-Modern art is often ornamental, even to the point of excess. While modernists attempted to throw off the past and strove for individual innovations, Post-Modernists appropriate liberally from the past, putting old information into new contexts. Post-Modern art is blatantly emblematic and eclectic, collecting imagery, techniques, and ideas from diverse sources, some recent, some far back in history. Where modernism tried to invent universal languages that captured the "now" and were self-evidently "true" (and therefore readable by all people everywhere), Post-Modernists tend to be realistic about the fact that understanding modernism helped create an elite of experts and that Post-Modernism also is difficult for many people. While modernism was metaphoric, sometimes hermetic, and enthusiastic about the potential of the times, Post-Modernists are more likely to be socially engaged in a direct sense, often skeptical, critical, and/or overtly political. While modernists tended

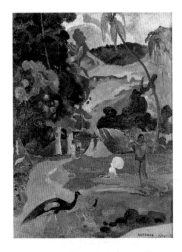

PAUL GAUGUIN (French, 1848–1903)
Landscape with Peacocks. 1899
Oil on canvas, 45¼ × 33⅞″ (115 × 86 cm)
Pushkin Museum, Moscow

to create signature styles and usually stuck to a single medium, Post-Modernists often change from one style to another, from one medium to others, and/or combine mediums in bold and fearless ways, using words almost as freely as they borrow images, subjects, and styles. While modernism's tenets proclaimed a hegemony that established an artistic mainstream, Post-Modernist eclecticism embraces great diversity, welcoming artists and styles that were relegated to modernism's margins.

Realism

Realist art strives to depict, with varying degrees of accuracy, "real and existing" things. The term sometimes applies to the choice of subject matter — in the sense of choosing to depict simple things relevant to the daily life of most people or that are penetrating psychologically. While some modern artists have been concerned with fool-the-eye accuracy, more often twentieth-century realists have been satisfied with rendering subjects recognizable while exaggerating various other aspects of the works in order to stretch their believability and encourage readings that penetrate the surfaces. In *The Knapsack* by Andrew Wyeth, we see a figure and setting that suggest a compelling narrative, but the scene is equally fascinating because of Wyeth's skill in creating believable light and shadows, space, and surface textures.

Surrealism

In their attempts to express and elicit the workings of the unconscious mind, often through fantastic or dreamlike imagery, Surrealists employ such techniques as unlikely juxtapositions, impossible behaviors, heightened reality, hallucinatory jumps, and other distortions of the recognizable. One branch of Surrealism abandons recognizable imagery altogether, attempting to let chance — "streams of consciousness" — or the properties of materials (wet, dripping paint, for example) produce undirected, unself-conscious paintings — truths beyond conscious thought or action. René Magritte's *The False Mirror* illustrates the strain of Surrealism that sets up the impossible in the manner of dreams or fantasy.

Symbolism

This movement in art and literature, which flourished from the 1880s to 1910, sought to represent subjective ideas, spirituality, and the truth of myth instead of objective reality. Symbolists were fascinated by such subjects as the occult, eroticism, and death. Although there is no stylistic continuity among them, Symbolist artists such as Odilon Redon (see p. 83) share a common tendency to use images and words to suggest reality beyond the physical plane, in which people and objects are merely symbols of a greater metaphysical truth. Symbolism is often seen as a forerunner of Surrealism.

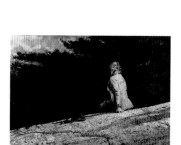

ANDREW WYETH (American, b. 1917)
The Knapsack. 1980
Watercolor on paper, 21½ × 29⅜″
(54.6 × 74.6 cm)
Private Collection

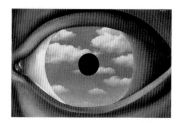

RENÉ MAGRITTE (Belgian, 1898–1967)
The False Mirror (Le Faux Miroir). 1928
Oil on canvas, 21¼ × 31⅞″ (54 × 80.9 cm)
Collection, The Museum of Modern Art,
New York. Purchase

SELECTED BIBLIOGRAPHY

Listed below are a few titles designed to tell you more about the artists included in this book. These books include general and/or stylistic histories of art, monographs on the artists as individuals, and museum and exhibition catalogues. Increasingly artists and styles are the subject of films and videotapes that are also available, although these tend to be more entertaining than serious. Such films and videotapes are not listed here but can be located in the catalogue and film collection of many libraries.

Arnason, H. H. *History of Modern Art: Painting, Sculpture, Architecture, Photography.* 3d ed. New York: Harry N. Abrams, 1986.

Ashton, Dore. *American Art Since 1945.* New York: Oxford University Press, 1982.

Atkins, R. *Art Speak.* New York: Abbeville Press, 1990.

Auping, Michael. *Abstract Expressionism: The Critical Developments.* New York: Harry N. Abrams, 1987.

Barr, Alfred H. *What Is Modern Painting?* 1943. Reprint. New York: The Museum of Modern Art, 1984.

Bourdon, David. *Warhol.* New York: Harry N. Abrams, 1989.

Castleman, Riva. *Printed Art: A View of Two Decades.* New York: The Museum of Modern Art, 1980.

————. *Prints of the Twentieth Century: A History.* New York: The Museum of Modern Art, 1976.

Chipp, Herschel B. *Theories of Modern Art.* Berkeley: University of California Press, 1968.

Crichton, Michael. *Jasper Johns.* New York: Whitney Museum of American Art/Harry N. Abrams, 1977.

Descharnes, Robert. *Dali: The Work, The Man.* New York: Harry N. Abrams, 1984.

Elderfield, John. *Frankenthaler.* New York: Harry N. Abrams, 1987.

————. *The Modern Drawing: 100 Works on Paper from The Museum of Modern Art.* New York: The Museum of Modern Art, 1983.

————. *The Wild Beasts: Fauvism and Its Affinities.* New York: The Museum of Modern Art, 1976.

Faulkner, Ray, Edwin Ziegfeld, and Howard Smagula. *Art Today.* 6th ed. New York: Holt, Rinehart and Winston, 1987.

Franck, Helen. *An Invitation to See.* New York: The Museum of Modern Art, 1973.

Goldberg, RoseLee. *Performance Art: From Futurism to the Present.* Rev. and enlarged ed. New York: Harry N. Abrams, 1988.

Goldwater, Robert. *Paul Gauguin.* Concise ed. New York: Harry N. Abrams, 1983.

Green, Jonathan. *American Photography: A Critical History 1945 to the Present.* New York: Harry N. Abrams, 1984.

Harlem Renaissance: Art of Black America. Introduction by Mary Campbell; essays by David Driskell, David Levering Lewis, and Deborah Willis Ryan. New York: Harry N. Abrams, 1987.

Hobbs, Robert. *Edward Hopper.* New York: Harry N. Abrams, 1987.

Hunter, Sam. *The Museum of Modern Art, New York: The History and Collection*. New York: The Museum of Modern Art, 1984.

Hunter, Sam, and John Jacobus. *American Art of the 20th Century: Painting, Sculpture, Architecture*. New York: Harry N. Abrams, 1973.

———. *Modern Art: Painting, Sculpture, Architecture*. 3d ed. New York: Harry N. Abrams, 1991.

Jacobus, John. *Matisse*. New York: Harry N. Abrams, 1973.

Jaffé, Hans L. C. *Picasso*. Rev. ed. New York: Harry N. Abrams, 1981.

Janson, H. W., and Anthony F. Janson. *History of Art for Young People*. 3d ed. New York: Harry N. Abrams, 1987.

Lieberman, William S. *Art of the Twenties*. New York: The Museum of Modern Art, 1979.

Linker, Kate. *Love for Sale: The Words and Pictures of Barbara Kruger*. New York: Harry N. Abrams, 1990.

Lippard, Lucy. *Pop Art*. 1977. Reprint. New York: Oxford University Press, 1982.

Livingstone, Marco. *Pop Art: A Continuing History*. New York: Harry N. Abrams, 1990.

Lucie-Smith, Edward. *The Thames and Hudson Dictionary of Art Terms*. London and New York: Thames and Hudson, 1984.

McShine, Kynaston. *Information*. New York: The Museum of Modern Art, 1970.

Miller, Craig R. *Modern Design 1890–1990: The Design Collections of The Metropolitan Museum of Art*. New York: Harry N. Abrams, 1990.

New Art. Selected by Phyllis Freeman, Mark Greenberg, Eric Himmel, Andreas Landshoff, and Charles Miers. New York: Harry N. Abrams, 1990.

Newhall, Beaumont. *The History of Photography: From 1839 to the Present Day*. 5th ed. New York: The Museum of Modern Art, 1982.

Pablo Picasso: Guernica; the Forty-Two Sketches on Paper. Introduction by Marie-Laure Bernadac. New York: Harry N. Abrams, 1990.

Rewald, John. *Post-Impressionism: From Van Gogh to Gauguin*. New York: The Museum of Modern Art, 1978.

Rubin, William. *Dada, Surrealism, and Their Heritage*. New York: The Museum of Modern Art, 1968.

———. *Picasso and Braque: Pioneering Cubism*. New York: The Museum of Modern Art, 1989.

———. *"Primitivism" in Modern Art*. New York: The Museum of Modern Art, 1984.

Russell, John. *The Meanings of Modern Art*. New York: The Museum of Modern Art, 1981.

Sandler, Irving, and Amy Newman. *Defining Modern Art: Selected Writings of Alfred H. Barr*. New York: Harry N. Abrams, 1986.

Shapiro, Meyer. *Cézanne*. Rev. ed. New York: Harry N. Abrams, 1962.

———. *Van Gogh*. Rev. ed. New York: Harry N. Abrams, 1969.

Stern, Rudi. *The New Let There Be Neon*. Rev. ed. New York: Harry N. Abrams, 1988.

Szarkowski, John. *Looking at Photographs: 100 Pictures from the Collection of The Museum of Modern Art*. New York: The Museum of Modern Art, 1973.

Taylor, Joshua. *Learning to Look: A Handbook for the Visual Arts*. Chicago: University of Chicago Press, 1981.

———. *Futurism*. New York: The Museum of Modern Art, 1961.

Varnedoe, Kirk. *A Fine Disregard: What Makes Modern Art Modern*. New York: Harry N. Abrams, 1990.

Waldman, Diane. *Arshile Gorky*. New York: Solomon R. Guggenheim Museum/Harry N. Abrams, 1980.

———. *Jenny Holzer*. New York: Solomon R. Guggenheim Museum/Harry N. Abrams, 1989.

———. *Willem De Kooning*. New York: Harry N. Abrams, 1987.

Weinhardt, Carl J., Jr. *Robert Indiana*. New York: Harry N. Abrams, 1990.

INDEX

Photograph Credits

The publisher and author wish to thank the museums, galleries, artists, and private collectors named in the captions for supplying the necessary photographs. Other photograph credits are listed below by page number.

Adelman, Bob: 90. Copyright 1990 Art Institute of Chicago: 28, 46 above. Courtesy of Mary Boone Gallery, New York: 136. Feature, New York: 145. Richard Feigen Gallery: 151. Peggy Guggenheim Foundation: 61. Hagen Charles, Copyright 1985 Artforum International: 9. Heald, David: back cover, 146 above. Copyright 1991 Indianapolis Museum of Art: 94. Bill Jacobson Studio, New York: 101. Lame, Larry: 135 below. Copyright 1991 The Museum of Modern Art, New York: front cover above and all other reproductions as indicated by caption. Sponsored by the Public Art Fund: 133. Reich, Adam: 89. Volz, Wolfgang, Copyright 1983 Christo: 98–99. Watson, Simon: 127 below. John Weber Gallery: 97. Trachtenberg, Marvin: 146 below. Zindman/Fremont, New York: 123, 125, 127 above

Illustration copyrights:

ARS, New York, copyright 1991: Front cover, 12, 74, 77, 82, 91 below, 114, 115, 154 below. ARS/ADAGP, Paris, copyright 1991: 8, 18 right, 51 above, 54, 55, 61, 147 above. ARS/LES HERITIERS MATISSE, Paris, copyright 1991: 35 below, 48, 49, 58 above, 84–85, 86, 149. ARS/ SPADEM, Paris, copyright 1991: 6, 23 below, 46 above, 60, 62, 67, 106–7, 110, 111, 141, 150 above. VAGA, New York, copyrights 1991: 9, 15, 23 above, 33, 50, 90, 118–19, 143, 147 below. VAGA/BEELDRECHT, Amsterdam, copyright 1991: 39, 44. VAGA/BILD-KUNST, Bonn, copyright 1991: 20. VAGA/PRO LITTERIS, Zurich, copyright 1991: 46, 80, 91. VAGA/ SIAE, Rome, copyright 1991: 42

Editor: Harriet Whelchel

Designer: Dana Sloan

Photo Research: Johanna Cypis, Catherine Ruello

Library of Congress Cataloging-in-Publication Data

Yenawine, Philip.

How to look at modern art / by Philip Yenawine.

 p. cm.

Includes bibliographical references and index.

ISBN 0–8109–2485–4

 1. Art, Modern—20th century. 2. Art appreciation. I. Title.

N6490.Y46 1991

701′.1—dc20

 91–10M152

 CIP

4398

HOW TO LOOK AT MODERN ART

by Philip Yenawine

HARRY N. ABRAMS, INC., PUBLISHERS, NEW YORK

This book is dedicated with love to Tad and Rebecca;
Penny, Rena, and Phyllis; Gregory and Juan; and Amelia,
Nancy Lee, and Catherine

The interplay of vision and thought is central to much of twentieth-century art. In this seemingly real yet lashless close-up of an eye, with its "partly cloudy" iris, Surrealist René Magritte sets up a witty, unlikely juxtaposition, a play on images called *The False Mirror*. In so doing, he uses the skills of a Realist to remind us that art can deceive, as the eye can, leaving it up to the mind to figure out what is going on.

Painter Frank Stella is not satisfied simply to make paintings of geometric elements; he often turns the actual canvases into geometric forms. Here, he has filled a huge circle with protractor shapes; following their interlocking patterns contributes to a sense of play, a quality that is heightened by bright, contrasting colors. Although self-contained and, according to Stella, "about" nothing beyond what you see, some shapes are completed by the mind's eye outside the canvas, and this helps us perceive painting as part of a continuum of the decoration and visual information that fill out world.

In contrast to the work of Frank Stella, Mark Rothko's soft-focus geometry seems to provide a logic within which to examine deep emotions. These dark blocks, their edges blending into surrounding blue, become a somber, meditative space, perhaps embodying sadness, loneliness, or pain. They seem both separate from and a part of the comforting blue atmosphere. Below, an evanescent white cloud, ironically supporting the weight of darkness above, allows us to be drawn into an intense emotional expression without feeling desolate.

CONTENTS

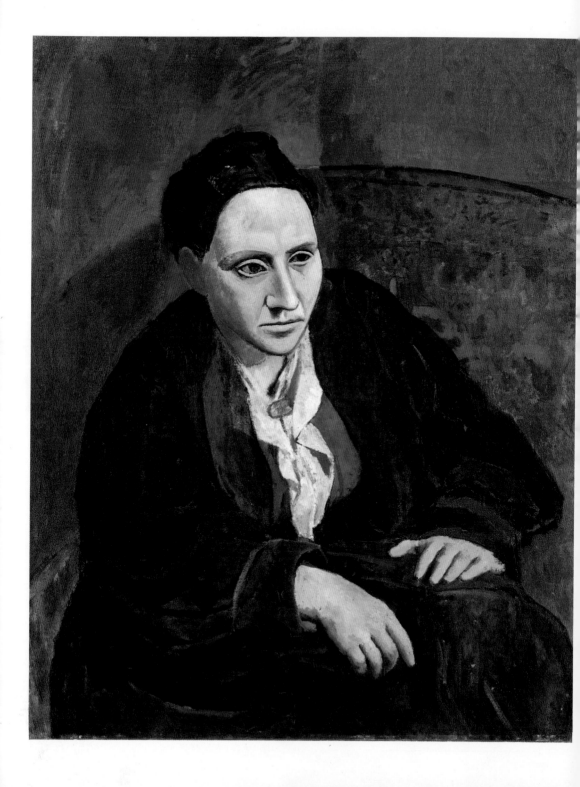

PREFACE

PABLO PICASSO (French, b. Spain, 1881–1973)
Gertude Stein. 1906
Oil on canvas, 39¼ × 32″ (99.7 × 81.3 cm)
The Metropolitan Museum of Art, New York. Bequest of
 Gertude Stein, 1946

Although there are a number of bold and heroic
figures in twentieth-century art, none is more
prominent than Pablo Picasso, whose inventiveness and
creative longevity alone set standards, both awesome
and devastating, for others. No artist can work without
making comparisons to Picasso. His ability to shift
from one style, subject, or medium to others, to work
in more than one style at a time, and to disregard
propriety, tradition, and respect for such things as
materials make it necessary for all artists to see their
work in terms of his ground-breaking genius.

In a landmark painting of 1906, Picasso labored to
create an appropriate portrait of his patron Gertrude
Stein. Most of the painting shows the influences of
tradition, but Stein's face is treated in a wholly
distinctive radical way. Despite similar light colors on
the hands and collar, the face shines more brilliantly.
The smooth brushwork, the precise outlining of chin
and brows, the sculptural quality of the irregular eyes,
and the overall masklike impression give the face a
completely distinctive feel from the rest of the
painting, an inconsistency that might look like a
mistake in a lesser artist.

I Know You Can Do It

As an art teacher obsessed with the idea that art is
vital to our well-being, I am convinced that the art
of our time is an accessible resource of various
heady and interesting ideas and sensory pleasures.
This book is conceived as a device for developing
more skills and more commitment to apply to the
task of mining modern art for what it can bring to
our lives.

To start requires little background, although a
spirit of open inquiry is essential. We then need to
use our eyes in a more demanding way than is
normal. The thinking process begins as we relate
what we see to things we know; we also need to
probe the evidence, to contemplate and speculate
about meaning. Ultimately, we need to evaluate what
we see and decide whether or not it is of long-term
interest and value to us.

Most of this is a matter of honing and
intensifying skills we already have. Furthermore, it
can be interesting from the start; we can, in fact,
cut our teeth on the most complex and interesting
works. While with literature one may need to start
with simple books and graduate to more difficult
and rewarding ones, in visual art it is easiest to start
at the top: the more visually and intellectually rich
the work, the more there is to grasp and ponder,
perhaps especially for the novice.

This book will concentrate on "directed looking" —
seeing what can be learned from examining works
of art rather than from acquiring background
information. This text therefore omits much art-
historical data on the assumption that there is a
time and a place for everything. This is the time for
looking, for thinking, and for trying to make sense
out of our world by seeking insight directly from art
objects, a process that becomes increasingly fruitful
with more experience.

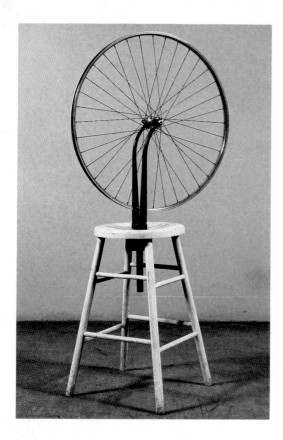

MARCEL DUCHAMP (French, 1887–1968)
Bicycle Wheel (third version, after lost original of
 1913). 1951
Assemblage: metal wheel 25½″ (63.8 cm) diameter,
 mounted on painted wood stool 23¾″ (60.2 cm)
 high; overall 50½ × 25½ × 16⅝″
 (128.3 × 63.8 × 42 cm)
Collection, The Museum of Modern Art, New York. The
 Sidney and Harriet Janis Collection

Perhaps more than any other artist, Marcel Duchamp
set modernism on a convention-defying course by
creating sculpture out of readymade objects never
intended as art in the first place. Not only does he
challenge notions of aesthetics and preciousness, but
he also raises the question, Is creativity an issue of
objects and craft—or of action, imagination, and
ideas?

Let's Remember the World We Live In

This book is not an apology for modern art. Instead,
it is conceived as a small antidote to ground swells
of discontent about the assaults and heresies of
contemporary artists. This discontent takes various
postures of indignation, including "get rid of it"
campaigns targeted against some public sculpture.
While acknowledging the legitimacy of negative
responses, I shall assert that these heresies have
happened in a world where Sigmund Freud, Henry
Ford, Albert Einstein, Robert Oppenheimer, Adolf
Hitler, Mahatma Gandhi, Martin Luther King, Jr.,
Richard Nixon, and Mikhail Gorbachev (to name a
few) have blown the socks off every assumption we
have made.

 Can we expect artists who know of the Holocaust
or who fear nuclear extermination to make com-
fortable, pretty art? Some will, but it is no more
reasonable to expect artists to avoid expressions of
their pain or their aspirations for a better world than
to expect the homeless to ignore the plenty that
surrounds them and those of social conscience to
forget the need for reform.

RICHARD SERRA (American, b. 1939)
Tilted Arc. 1981
Cor-Ten steel, 12 × 120′ (3.6 × 36 m)
Courtesy of Leo Castelli Gallery

Serra's sculpture epitomizes some aspects of twentieth-
century culture in his use of raw and unadorned
materials, overpowering scale, and tenuous
equilibrium. His work consistently produces controversy,
and, in fact, this particular sculpture was removed
from New York City's Federal Plaza after a long battle.
The public outcry is its own testimony to Serra's clear
impact on audiences, albeit negative in this case.

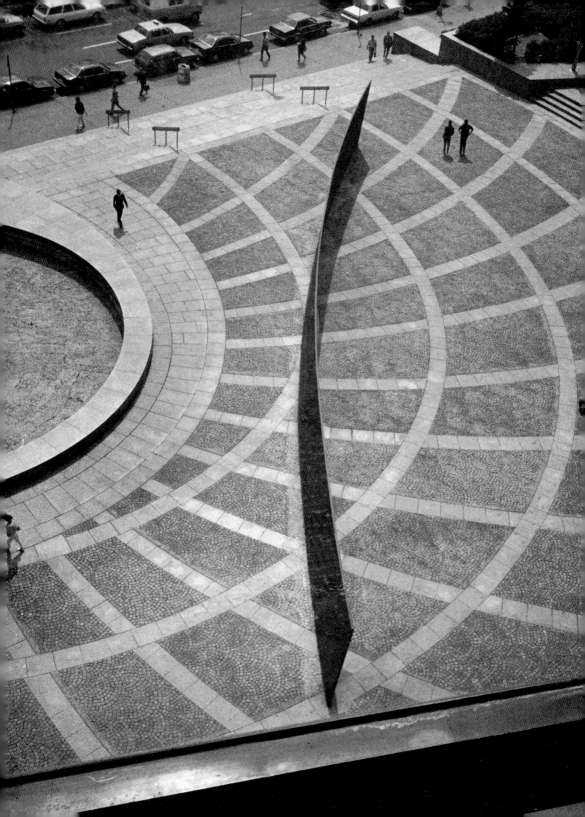

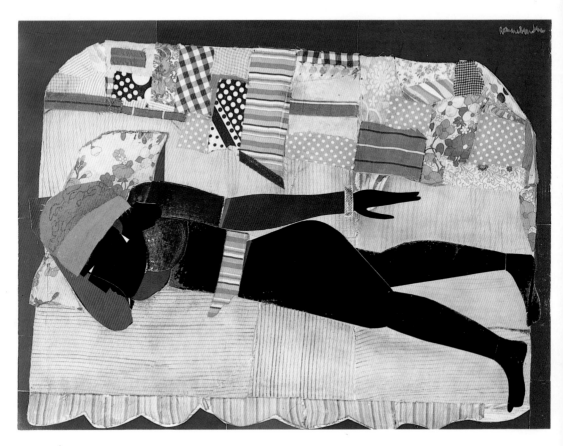

ROMARE BEARDEN (American, 1914–1988)
Patchwork Quilt. 1970
Cut and pasted cloth and paper with synthetic polymer
 paint on composition board, 35¾ × 47⅞″
 (90.9 × 121.6 cm)
Collection, The Museum of Modern Art, New York.
 Blanchette Rockefeller Fund

An African-American artist, Romare Bearden combined
various folk idioms with influences as diverse as
ancient Egyptian art and the colorful paintings of
Henri Matisse. The confluence of styles, starkness of
contrasts, and the argument between the comfort
of the bed and the figure's rigidity all contribute to the
work's imposing presence.

The Issue of Mainstreams and Margins

This guide mostly plays into the notion of the "mainstream" — an established body of modern art that is "good and important," arrived at by consensus among those who have the authority to exhibit, write about, buy, and sell it. In order to maintain a tight and ineluctable logic, the mainstream's existence, by definition, requires that substantial numbers of nonconforming artists be overlooked or considered odd culs-de-sac and anomalies. This means that there exist many unrecorded players of the past and present and others who are certainly marginalized and not seriously acknowledged.

While this book includes some work that has been relegated to fringe status, it concentrates on major artists and acknowledged masterpieces because such work is familiar to more people. Given the fact that many artists and others cut their teeth on it, it seems appropriate to focus on mainstream art instead of asking this introductory book to do more than admit that there are still wrongs to be righted and omissions to be redressed. As you look both here and elsewhere, however, remind yourself that what you see is not, by any means, all there is.

What follows are several chapters, some of which try to clarify the logic behind certain artistic challenges, giving a context for understanding modern art, while others address ways of decoding artworks in order to get at meanings that at first might seem elusive. It is my intent to convince you that modern art is pertinent to our daily lives, and that it is possible to understand it. In fact, I firmly believe that we cannot function fully and creatively as human beings in art's absence. To "use" it, however, we need to alter certain expectations and, as we decode it, let art draw us into a lively dialogue with issues that concern us. If we do, we can serve our distinctly twentieth-century needs.

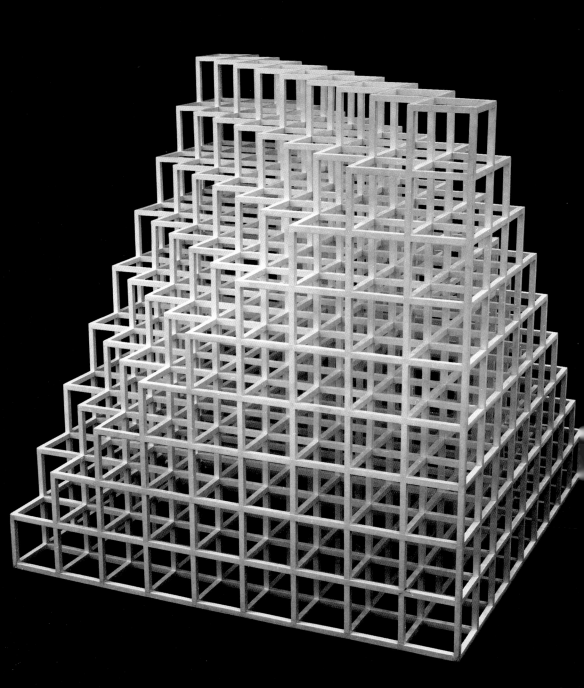

SETTING THE STAGE

Sol LeWitt creates work that involves preparing a set of extremely precise instructions that are usually executed by others, often industrial fabricators. Branded a Minimalist because of the way he limits his range of colors, materials, and geometric motifs, LeWitt explores space by working in very large scale, and shape by repeating his chosen motif—which is often a square, a form never found in nature but omnipresent within human constructions. LeWitt asks us to become conscious of our perceptions of form and materials in the environment; the aesthetic message in part comes from enhanced awareness.

We live in a time when art often appears to be an alien language. This statement does not imply that artistic tradition is wholly overlooked, of course. There are artists who produce recognizable, perhaps even beautiful, images out of materials we respect. Some have impeccable command of craft. But more often our expectations are thwarted by confrontations with inappropriate materials and techniques, over-whelming scale, mechanical repetitiveness, blatant politics or sexuality, impermanence, and/or ugliness. We are confounded by unclear or mixed messages. We are sometimes offended by simplistic or sloppy craftsmanship; we know we could do that. What's the fuss? What does it all mean, anyway? we ask. Why is this art?

To make matters worse, most cultural activity happens in an odd arena called the "art world," confined to facilities often physically distant and sometimes psychologically remote, cold, or unwel-coming. We therefore often feel a distance from the "emperor's new art" and its forbidding environs. Both the lack of accessible meanings and the off-putting look of much art contribute to a sense that art is an elitist enterprise, perhaps even a sham.

It is somewhat ironic that, despite constant worldwide communication by way of various technologies, we have no guarantee that Jackson Pollock's abstract paintings mean similar things to adults and children, or to art historians and agricultural workers, if in fact they mean anything at all to the uninitiated. Similarly, although we may know of aboriginal painting from Australia, we may not understand either its technique or its message unless we are part of or deeply informed about that culture.

Turning our backs on or rejecting art is too easy a response, however tempting it may seem. Art is still of utmost significance to our ability to engage

NAM JUNE PAIK (Korean, b. 1932)
Something Pacific (detail). 1986
One of 7 elements consisting of 24 working and 7
 nonworking televisions and bronze statues
Courtesy of the Stuart Collection, University of
 California, San Diego

Nam June Paik synthesizes complex cultural statements
that center on visual possibilities of "high-tech"
mediums, often combined with elements that embody
the past or suggest the eternal. Fast-paced video
imagery arrests our attention and, ironically, Paik
makes speed a subject of meditation. He values
ordinary things as an alchemist might, using his
artistry to convert them into "gold."

WILLEM DE KOONING (American, b. The Netherlands, 1904)
Woman, I. 1950–52
Oil on canvas, 75⅞ × 58″ (192.7 × 147.3 cm)
Collection, The Museum of Modern Art, New York.
 Purchase

Although his sources were the likes of huge billboards
with smiling females that from one standpoint might
be considered gross exaggerations, Willem de Kooning
can be seen as experimenting with an expressive
language of color, pose, gesture, and highly energized
brushwork to extend the conventions of female
depiction in a search for the elemental and
monumental, outside of time and specificity, and
certainly beyond beauty.

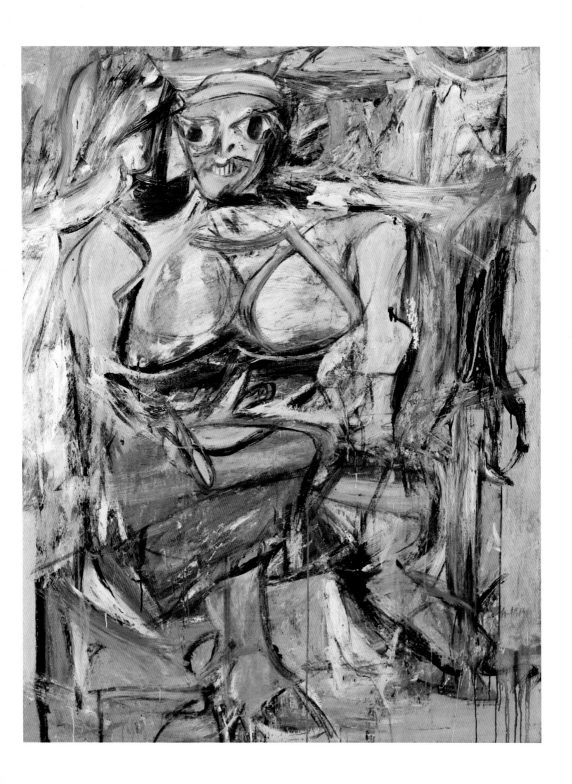

15

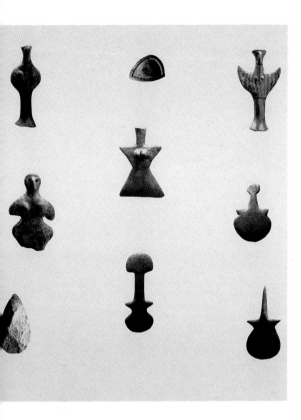

SARAH CHARLESWORTH (American, b. 1947)
A Grammar of Essence. 1990
Cibachrome, 40 × 40″ (101.6 × 101.6 cm)
Courtesy of Jay Gorney Modern Art

In a search for the primal meanings of femininity
wholly different from De Kooning's, Sarah Charlesworth
photographs a collection of what once were referred to
as fertility figures but which are now recognized as
representations of a goddess from the early Minoan
culture on Crete and the Cycladic Islands.
Charlesworth's photography is cool, detached, even
slick, particularly when compared to her subject. She
looks with reverence at archaic culture, yet her use of
a fashion medium adds an ironic tone and another
point of view to the visual dialogue between De
Kooning's *Woman, I* and the objectified woman of
advertising.

meaningfully with the world, just as it always has
been. Although it often looks radically different from
art of the past, it continues to contain useful
messages in spiritual, inspirational, and even quite
rational terms.

Confusion may stem partly from not-so-deeply
buried memories of yesterday. As recorded in the
histories of most cultures, the traditional role of art
was based on accepted conventions. It was appro-
priately crafted out of predictable materials. It was
also functional—sometimes in the direct sense of a
bowl or tapestry, sometimes in more spiritual or
didactic terms—and it served to explain and express
a culture's myths, containing symbols and subjects
that were universally recognized and meaningful
within that culture.

Powerful and magical, art embodied things that
people believed and, in fact, often had the function
of teaching the young as well as reminding others in
the community of important truths. As such, art was
both integral and essential; its messages were clear
to people, probably the way television is today.

Art could function in this way—as a universally
understood system—because it was localized within
a relatively homogenous and somewhat static
community. Our "community" today, on the other
hand, is worldwide, extremely diverse, and rapidly
evolving; even nationally we are a multifaceted
people, lacking the coherent and stable culture of
our predecessors. This diversity argues against the
possibility of creating an art understood by all.

It is also important that, throughout most of
history, including when Chartres was built, and even
later, when Gilbert Stuart painted portraits of George
Washington, most people could not read.
Recognizable images presented in art were thus
essential to teach and inspire. The crucifix and the
kachina taught people about spiritual matters,

however much they inspired aesthetic responses as well. The majority of people in the industrialized world today are literate, however, and information in ever-escalating amounts is available by way of a range of printed media, television, and film. In a direct sense, art has been replaced as a source of education, which has been formally left to schools.

But while teachers, texts, and television may have subsumed art's role as information bearer and educator, they do not convey the meanings that art brings to our existence with the same richness and complexity. This is why artists still feel compelled to create and why the rest of us still seek art out. It also helps explain our disappointment and frustration when we encounter art we do not understand.

Let us take a step back here. Consider what we want art to do, which I would summarize as to provide visual devices that attempt to give form to ideas, beliefs, and values that are both essential and elusive, if not inexplicable. Art is supposed to operate as a medium of communication—which implies that we understand it—acting as an outward sign of interior truths. But if television states the obvious, art probes the mysterious.

Dealing with the experience of a rapidly changing world—one that often seems bewildering—has led modern artists to search for a vocabulary to describe, for example, psychology's discovery of the unconscious, which is one reason why in his painting *The Birth of the World,* Joan Miró relied upon abstract imagery and aspects of chance to fathom creation. Käthe Kollwitz chose another language to help comprehend the unconscionable acts of inhumanity that persist in our times, as seen in her *Death, Woman and Child.*

Artists have persisted in using realistic images to refer to literal experience in order to help viewers make connections with their own lives. One possible key to Pablo Picasso's immense popularity is the fact that he virtually never abandoned references to the real world in his work. He maintained semblances of realism while achieving unprecedented creativity. This allowed him an audience among both those who want recognizable imagery and those who admire innovative virtuosity.

Equally often, artists have turned to abstraction to isolate and interpret essential, invisible qualities, such as dynamism of a machine age, as expressed in Umberto Boccioni's *Dynamism of a Soccer Player,* or feelings such as insecurity or rage at injustice. The recognition of the "globe as village," interconnected and interdependent, has also been a motivation for seeking universal languages that might transcend barriers of place and time, particularly in the early part of the century. This is perhaps another reason for abstraction, which could be described as an attempt to find vocabularies that are so generalized that they are universally understandable.

Modern artists have often felt compelled to assert their own uniqueness also, emphasizing self-expression and individual identity, as perhaps another response to the sense of oneself as a tiny part of a global village with ever-expanding populations. Such individual assertiveness has led to the creation of highly personal styles, with each artist looking for a way of establishing his or her own signature set of subjects, materials, and techniques. This has created amazing diversity—and quite a job for the viewer.

Diverse means of expression are also encouraged by the way contemporary society prizes inventiveness and innovation. "Make it new," intoned poet Ezra Pound as a way of saying, Show me something I have never seen before. "Astonish me," ballet

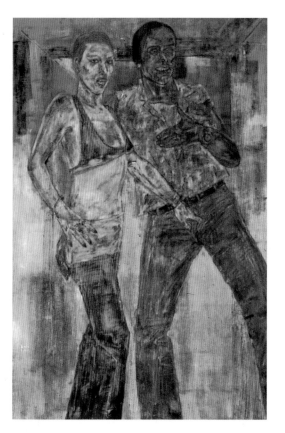

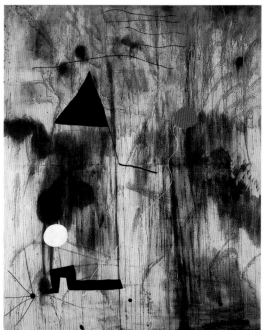

LEON GOLUB (American, b. 1922)
Horsing Around, I. 1982
Acrylic on canvas, 10′ × 6′8″ (304.8 × 203.2 cm)
Courtesy of Barbara Gladstone Gallery, New York

Leon Golub takes an irreverent posture with regard to
both subject matter and painting techniques in order
to create images that are more revelatory than
inspirational. Depicting here a certain kind of sexual
play for its nasty competitiveness, he emphasizes the
unkind, unwarm hostility of certain games between the
sexes. The people seem individualized yet are
depersonalized, animalistic, crude, and vulgar—
attributes that are emphasized by the cartoon-like
drawing and the smudgy black paint that hazes over
the entire image. The painting looks like one's fingers
after reading a newspaper, in this case probably a
tabloid.

JOAN MIRÓ (Spanish, 1893–1983)
The Birth of the World. 1925
Oil on canvas, 8′2¾″ × 6′6¾″ (250.8 × 200 cm)
Collection, The Museum of Modern Art, New York.
Acquired through an anonymous fund, the Mr.
and Mrs. Joseph Slifka and Armand G. Erpf Funds,
and by gift of the artist

In trying to fathom and then depict creation, Joan
Miró settled on two different techniques for creating
abstractions. The first is apparent in the background of
this painting, where a very thin veil of dripping paint
seems almost to have happened by accident, regardless
of the artist's efforts. The second is seen in the
carefully drawn lines and forms, which take on
associative shapes, such as creatures or celestial bodies,
suggesting perhaps that out of chaos and darkness, life
begins.

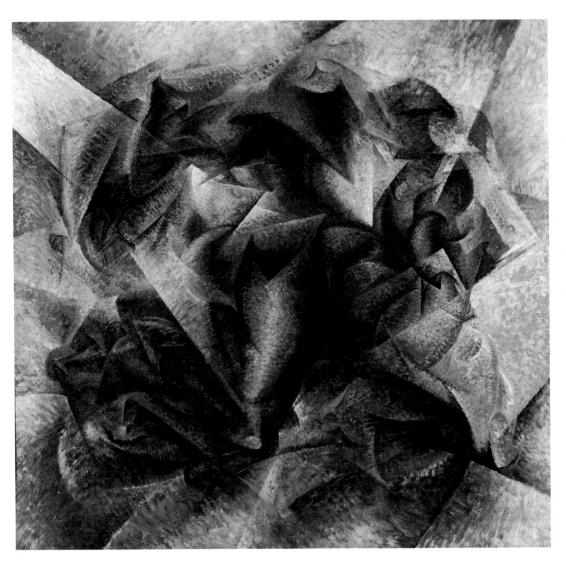

UMBERTO BOCCIONI (Italian, 1882–1916)
Dynamism of a Soccer Player. 1913
Oil on canvas, 6′4⅛″ × 6′7⅛″ (193.2 × 201 cm)
Collection, The Museum of Modern Art, New York. The
 Sidney and Harriet Janis Collection

Boccioni was part of a group of Italian artists (the
Futurists) who united around a theory that modern art
should focus on the incredible positive power and
speed of which the mechanical world was capable. He
extracted the dynamic exertion of an athlete to create
this spinning circle of brightly colored energy.

KÄTHE KOLLWITZ (German, 1867–1945)
Death, Woman and Child. 1910
Etching, printed in color, 16⅛ × 16³⁄₁₆″ (41 × 41.2 cm)
Collection, The Museum of Modern Art, New York. Gift
 of Mrs. Theodore Boettger

Perhaps anticipating Europe torn by war and its
aftermath, but in any case identifying particularly
with a mother's relationship to struggles for life and
death, Käthe Kollwitz usually depicted her pain in
black drawings and prints, finding that lines and
forms of that single, somber color, in contrast with
white paper, were a sufficient vehicle to tell her
gripping story.

impresario Sergey Diaghilev begged Jean Cocteau
when, at the beginning of the century, he sought a
new look for dance. To people like Picasso, who
helped define artistic inventiveness and freewheeling
exploration, these admonitions were music. A frenzy
of discarding old ways, blazing trails, and finding
ways of building anew on old foundations produced
"modernism," a dutiful and undaunted search to
find new things under the sun.

Modernism's history, then, is one of redefining
art's roles, methods, parameters, and meanings, and
it should be no surprise that artistic traditions or
existing conditions have not been binding. Artists,
like scientists, have refused to believe in limitations
and impossibilities and thus have striven to break
boundaries and surpass expectations.

Artists have also shared the century's romance
with technology. They are open to new mediums and
materials that technologies provide, particularly if no
one else has thought to use them. Artists have thus
begun to find many uses for cameras, to "paint"
with neon, and to "draw" with computers. The use
of machines and mechanical techniques has
redefined what craftsmanship means. In fact, many
artists have begun to exhibit a rather casual attitude
toward technical know-how, and craft is no longer a
strict measure of artistic success.

This does not signal a disinterest in materials,
however. Whole styles have evolved out of enthusiasm
for particular properties of paint, for example. Much
of what is known as Abstract Expressionism gets its
meaning from how paint in various thicknesses,
applied by a variety of means, behaves differently
and affects the finished work in different ways. Blobs
of paint mean something different from drips or thin
veils. Artists have displayed the sensitivity of wine
connoisseurs in their appreciation of the sensory
properties of materials—not only paint, but also

NANCY BURSON (American, b. 1948)
Warhead I. 1982
Black-and-white composite photographic image,
 8 × 10″ (20.3 × 25.4 cm)
Courtesy of Jayne H. Baum Gallery

Using computer-graphic implements, Nancy Burson combines photographs of people, often obtaining them secondhand from sources such as television, to create distinctly twentieth-century group portraits. By overlaying photographs of the heads of the nations that have nuclear arsenals, Burson creates the ultimate "power portrait," a gruesome reminder that destruction of the world is within the grip of a few mortals.

many types of metals and natural substances as well as highly artificial, even electronic ones.

Fascination with technology, especially the content and form of communication media, has actually led to wholly new art forms, such as video and computer-generated art, and certainly to new imagery and techniques, as we can see in Pop Art. Simultaneous with delight in the new, there has been a thorough search of "the past," which is extremely rich and diverse, especially if one looks beyond European history for information. A source from the past that has supplied vast inspiration is the art of tribal peoples. Admired for its direct relation to the materials from which it is made, as well as for its simplified forms and its use of color to enhance expression, so-called primitive art (a term usually replaced with tribal art at present because of the former's pejorative connotation) has influenced a great number of artists. Whether intrigued by the power of its design or captivated by its presumed directness and primal qualities, modern artists have appropriated its forms in order to cut through layers of what they considered to be civilizing influences to get down to basic and essential truths. Pablo Picasso is known for such enthusiasm, beginning as early as 1907.

While this context helps explain why the art of today looks different from earlier art, it also accounts for some of our confusion. Instead of being general knowledge, knowing about art seems to be a skill, requiring specially gained expertise or at least a great deal of exposure and experience. Art is thus not unlike specialties in medicine or, for that matter, the work of mechanics who repair Chevrolets, not Fiats. But while we accept this specialization in many areas of activity, we do not like feeling distanced and inexpert when it comes to art.

Central to the problem this creates — and one of its most off-putting aspects — is that, in large measure, the *idea* has often replaced the object as the center of art. This is clearly disappointing to some degree — where is the wonderful, meaningful object we can love? The strength of idea-based art, however, is that it forces us to think.

While a newscast essentially predigests information, current art is configured to make us chew for ourselves. It provides certain concrete data, but good art is inherently full of ideas and implications that go beyond the concrete and the obvious. It is by delving into the mix of visual, tactile, or auditory information and defining its illusive content — ideas — that we find much of its aesthetic appeal. The analogy to television can be usefully extended here: the process of sifting through the various biases of televised information, deciding what seems most likely to be accurate and what best reflects our own values, and then responding accordingly, is itself a mirror of the complex action involved in coming to understand art. Creative thinking is at the center of both.

It is helpful, therefore, if we begin with open minds and acknowledge that thinking is both the requirement — and the pleasure — of meaningful encounters with art. We might also seek out more frequent intersections between art and ourselves, and might further want instruction in artistic motives and methods; museum staff and art writers, who have made it their purpose to understand, need to explain to the rest of us what is going on in terms and contexts that we can understand. We might also fight for a higher priority for art in schools, a logical place for the rather simple instruction necessary to make us feel visually literate.

If we let them, the arts invite us to participate variously in pleasure, mayhem, beauty, challenge, insight, sadness, stimulation, inspiration, humor,

JAMES ROSENQUIST (American, b. 1933)
Marilyn Monroe, I. 1962
Oil and spray enamel on canvas, 7′9″ × 6′¼″
 (236.2 × 183.3 cm)
Collection, The Museum of Modern Art, New York. The
 Sidney and Harriet Janis Collection

Having complete control of the painting and drawing
techniques required to produce convincing illusions of
the physical world, James Rosenquist applies this gift
to the recycling of imagery found in advertising and
scaled to the size of billboards, thus earning him the
label of Pop artist. Instead of straightforward depiction,
he fragments, overlays, and intercuts a variety of
recognizable subjects and words. He thus draws us in
with the familiar, but as he does he also asks us to
probe the complexity of being immersed in a culture
too often satisfied with superficiality.

PABLO PICASSO (French, b. Spain, 1881–1973)
Les Demoiselles d'Avignon. 1907
Oil on canvas, 8′ × 7′8″ (243.9 × 233.7 cm)
Collection, The Museum of Modern Art, New York.
 Acquired through the Lillie P. Bliss Bequest

Part of the power of this confrontational painting—
where angularity, harsh colors, crude depiction, and
cramped space all tend to alienate the viewer from
these theoretically seductive prostitutes—derives from
the artist's inclusion of tribal, masklike faces on two of
them. Picasso probably borrowed these simplified and
distorted forms because he perceived in them a kind of
primal authority that transforms the ordinary into
something earthier, raw and strong.

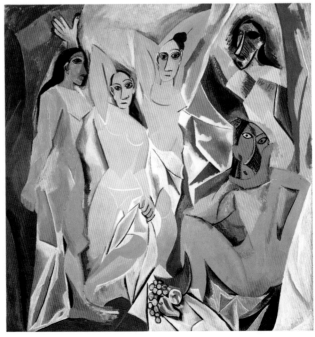

Dear Friend,
 I am black.
 I am sure you did not realize this when you made/laughed at/agreed with that racist remark. In the past, I have attempted to alert white people to my racial identity in advance. Unfortunately, this invariably causes them to react to me as pushy, manipulative, or socially inappropriate. Therefore, my policy is to assume that white people do not make these remarks, even when they believe there are no black people present, and to distribute this card when they do.
 I regret any discomfort my presence is causing you, just as I am sure you regret the discomfort your racism is causing me.
 Sincerely yours,
 Adrian Margaret Smith Piper

ADRIAN PIPER (American, b. 1948)
My Calling (Card) #1. 1986
Reactive guerilla performance (for
 dinners and cocktail parties):
business card, 2 × 3½″ (4.54 × 8.89 cm)
Courtesy of John Weber Gallery, New York

As Picasso took from tribal art and
Rosenquist from advertising media,
Adrian Piper adapts the modest form of
the business card to make an artwork
that depends on its verbal message more
than its visual one to arrest the viewer.
Piper hands these cards out in
circumstances that seem to call for
them—probably seeking to transform
consciousness—interpreting the role of
the artist as a multifaceted player on
life's stage rather than as a maker of
objects.

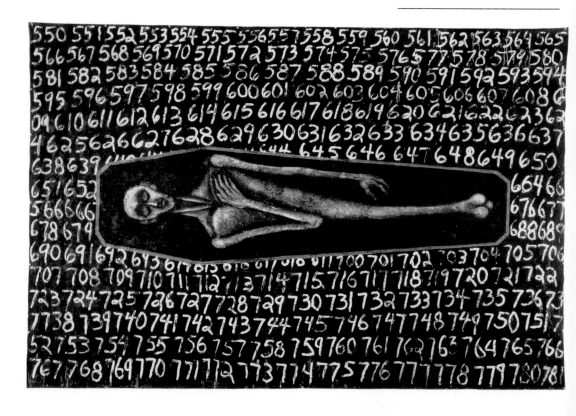

heightened awareness, disruption, delight, subversion, and so forth. While some of these qualities are not ones tradition has trained us to expect, they nonetheless make sense in the era that invented atomic bombs, space travel, and other things for which tradition has also not prepared us.

The thesis of this book, then, is that art is not supposed to be just beautiful, appropriate for a setting, or easy. Its most satisfying function is that it allows us to exercise our minds. An artwork will establish certain boundaries by its subject matter, style, materials, and techniques. It then lets us observe and analyze these givens by probing and musing. By finding its ambiguities, we can proceed in a game of speculation and interpretation.

We can indulge this pleasure as a meditation or as an act of communication with others. Since

LUIS CRUZ AZACETA (American, b. Cuba, 1942)
AIDS Count III. 1989
Acrylic on canvas, 6'5" × 9'9" (195.6 × 297.5 cm)
Courtesy of Frumkin/Adams Gallery

Luis Cruz Azaceta, who immigrated to the United States from Cuba as a young man, applies his understanding of alienation to the subject of AIDS, a disease that carries with it the taint of the outcast. He symbolizes AIDS's crippling effects by painting an emasculated and emaciated form, half-skeletal and maimed, lying in a coffin. Its blackened eyes stare, frightened but still vital. One hand is reduced to a claw, the other lies on its heart as if making a final pledge of allegiance. The coffin is surrounded by numbers, a faceless census of people who have died from the disease.

absolute right and wrong answers do not exist (even the intentions of the artist are no more "correct" than the conclusions we carefully sort out for ourselves), we need fear no authoritative judgment on our interpretations. To be sure, expert opinion and the artist's own views are interesting and can be highly informative, but they are just two views, no different from two expert opinions on the usefulness of war. They contribute to our thinking, but as they sometimes conflict with one another, they may also conflict with our own understandings. In any case, they do not invalidate our opinions, which are our right and responsibility.

This book will focus largely on paintings and other two-dimensional art, omitting most sculpture and architecture because they are so difficult to analyze without seeing them. The various avenues of approach we shall emphasize, however, can be applied to most works of art. These avenues are designed to help "enter" works of art; further searches must be conducted on one's own by extending the principles discussed. Searching out additional biographical and historical data can enrich the process; however, the direct experience of the object is the issue, digging into our own resources for definition of what we see, assigning our own set of meanings and judgments to the work. Presumably, we always have our eyes and minds with us, and, when we are out in the world looking, our own skills at observing, analyzing, and interpreting are what fill each day with new awareness.

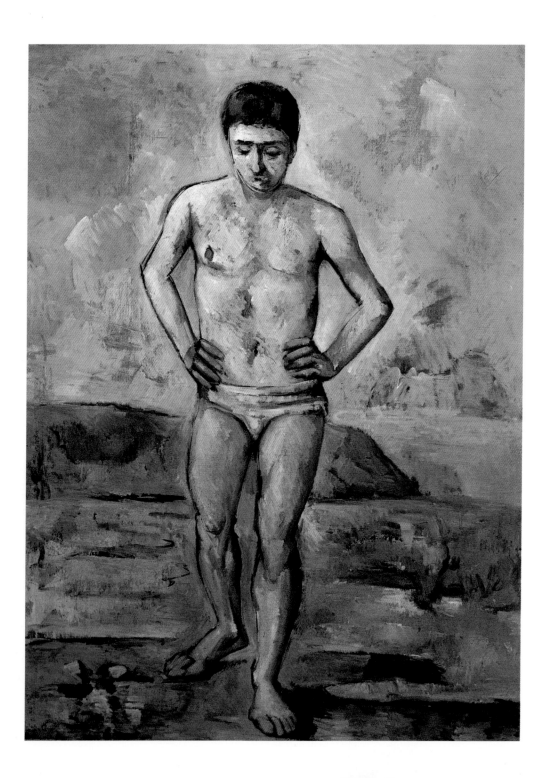

LOOKING FOR MEANING

The late-nineteenth-century French painter Paul Cézanne is looked upon by many as the "father" of modern art because so many of his explorations with color, shapes, subjects, and methods of painting had direct influence on the next several generations of artists. Younger artists turned to him for inspiration and example. One thing he taught them is that paintings can be highly calculated; they are idea based. *The Bather*'s pensive pose is a perfect symbol of Cézanne's approach to painting.

It is logical when looking at this picture to begin analyzing its apparent subject to find meaning: a man, almost nude, walking slowly in a landscape that is itself rather bleak. It is probably a beach with some marshy land at the right and some mountains nearby. A fairly gloomy day seems to be taking a turn for the worse, given the black mass forming at the upper left in the already cloudy sky.

The most important element in the painting is the man who stands front and center, practically filling the picture's space, as if about to step out of the picture. Despite his proximity to us and his almost life-size scale, he is not relating to us. His downcast eyes and general tentativeness keep him self-contained and distant. His self-involvement, the grayness of his mottled habitat, and the fact that he almost stands guard at the frame's edge are, however, only three reasons why we do not feel invited to join him in his painted world.

Let's look further at the painting's space, at how it is established and violated at the same time. For example, the mountains are painted indistinctly in order to appear far away from us, but then, both at top and especially at the bottom on the left, they are delineated by a heavy black line, very similar to the ones that outline the man's legs. Because of the line, both mountains and legs seem to exist on the same

PAUL CÉZANNE (French, 1839–1906)
The Bather. c. 1885
Oil on canvas, 50 × 38⅛" (127 × 96.8 cm)
Collection, The Museum of Modern Art, New York.
 Lillie P. Bliss Collection

plane. Thus, in one way Cézanne takes us deep into space, and in another he brings us right back to the painting's surface.

He does this elsewhere, too, by using black and white in a manner that defies logic. The optical property of black is to recede into the darkness of shadows and interstices. White, on the other hand, usually lifts off the surface, like reflected light. But in this painting, black is painted in the upper left in a thin film on top of suggestions of white clouds. In the lower right quadrant of the painting, white appears theoretically behind the bather, both near his leg and as highlights on parts of the grassy beach on which he is walking. These thin white daubs seem to serve no descriptive purpose, such as to simulate water sparkling with reflected light. Instead, both black and white confuse the eye and subvert

ADOLPHE WILLIAM BOUGUEREAU (French, 1825–1905)
Bathers. 1884
Oil on canvas, 79⅓ × 51" (201.2 × 129.5 cm)
The Art Institute of Chicago. A. A. Munger Collection,
 1901.458

To a generation of rebellious painters in the late nineteenth century in France, the conventions of academic painting seemed restrictive and lifeless, despite the consummate skill of painters such as Bouguereau and the ethereal beauty of their art, which we can still appreciate. To artists such as Cézanne, the concentration on skin tones and on perfect modeling of form; the creation of a believable if nondescript space; the languid, meaningless studio quality of the poses; and a lack of intellectual challenge or some other transcendent content were of no interest or value. Yet although the Impressionists bypassed this careful classicism, Cézanne studied it intently, appreciating its structure and its timeless qualities, wanting to incorporate its rigorousness into his work while adding intellectual zeal.

our expectations of space.

Similarly, the patterns of land, water, or clouds are interrupted slightly when they come close to his body. Not only does this seem to set off the man's energy as separate from that of the scene, but it also makes it harder to believe that there is a credible world in the painting. Any stories our imagination might weave to make us a part of this picture keep running aground.

Other color comparisons provide insight into Cézanne's intent to make us concentrate on paint and painting rather than story or illusion. For example, even though the bather's body contains more of the brighter, warmer tones than the background does, essentially the same colors are used throughout. To observe this, make comparisons between his left thigh and the sand next to it, or the lower part of that leg and the water nearby.

Also examine the outline that generally follows the contours of his body. No such line exists in nature, so including it is an act of painter's artifice, which separates the figure from its background. Moreover, where the line is broken, Cézanne deliberately lets foreground and background meld into one another.

Look also at the half circle that creates the man's chin. Not exactly where it should be, this off-kilter arc creates an awkwardly painted passage. Why the "mistake," and indeed why has Cézanne reduced the chin structure to a half circle when we know it isn't? Look at the feet and the elbows, reduced from well-rounded, natural forms to geometric shapes. Through such choices, Cézanne seems to emphasize geometry rather than naturalism, and this interest extends to the composition, also. For example, follow the line of the forward leg all the way up the body. Some demarcations on the bather's torso make sense anatomically while others seem to be random

Detail of *The Bather*

patches of paint, but together they establish a strong line that bisects the painting practically dead center. There is also a horizontal line created by the mountains on the left, which moves across his trunks and is inexplicably picked up in the clouds. This line almost equally bisects the painting top to bottom. Cézanne renders his bather in such a way that the man is both a human form and geometry, thus securing the figure's monumentality while establishing a stable structure for the painting.

Let your eyes skip around the painting to examine Cézanne's brushwork and note contrasts between where he seems interested in using careful strokes to help render light into shadow, for instance, and where he seems more to be making arbitrary marks than to be describing shapes and forms.

See if you can figure out precisely the direction of the light source by comparing highlights and shadows for location and intensity. Is the source consistent in strength and direction?

Again and again, Cézanne thwarts our expec-tations. It is as if he says we know what nature is, and we know that painted illusion is possible. With those as givens, then, let us examine what else paintings can be.

Draw back for another overall look at this man and his expression. Reconsider his pensiveness. How do the vagaries and contradictions of site and color expand on the mood set by his downcast, thoughtful pose? Do Cézanne's optical inconsistencies contribute to an impression of a state of quandary? What does the intentional "bad" painting (the arbitrary-seeming brushwork, for example) add to this sense of uncertainty?

Cézanne uses his painting technique to underscore the withdrawn tentativeness of his bather, combining subject and method to help us understand some-thing. Can you image what might have motivated

Cézanne to create a man on the verge of stepping into a new world, even a new century, yet looking so disengaged from it? What connections might any of these have with a man depicted shortly before the turn of the last century—and what now, at roughly the same point a century later?

I raise questions here because Cézanne seems to have done the same thing. He uses painting as a way of asking, Yes, but what if . . . ? He seems to address both what we expect to get from pictures and what other possibilities exist. More than to create a scene, tell a story, emulate a hero, or describe a virtue; more than to show how illusionistic techniques can make you see rounded forms and specific evocations of the appearance of different materials and phenomena such as light, Cézanne uses these devices only to establish reference points for us, essentially to ask, What is painting supposed to be?

This is a question most twentieth-century artists have adopted with delight as their own. In most cases their meanings are available to us in part through examination of their technique, as we just did with Cézanne. What follows in this chapter is a dissection of this process—breaking apart the activities of looking at subject matter, colors, lines, and other visual properties in order to glean various levels of meaning from a painting.

For the purpose of discussion, we shall establish five different categories of observation: physical properties, subject, illusionary and formal properties, and viewer perspectives. Each category is an avenue into an artwork, a way to begin looking for meaning. We shall examine these observational categories separately and put them into a sequence, although in actual practice they overlap.

Usually there is some outstanding feature that suggests how to begin looking at a work. One will,

for example, represent something so obvious that we have to begin with its subject matter, as in Cézanne's *The Bather.* Another will assert its compositional elements so strongly that picking out line, color, and shape will dominate initial observations. Whether we realize it or not, we usually start interpreting these observations immediately. For example, as soon as we identify a certain gray as "drab," we have begun the process of describing its effect and interpreting its meaning. For now, we shall isolate different kinds of observations in order to understand them better.

Physical Properties

Again, stressing that the steps outlined below are not, in real life, taken in a prescribed sequence and none is more important than the others, we shall begin our observing process by collecting physical data about a work. Basically, this entails acknowledging:
- How big is it and how does its height relate to its width?
- What mediums (paint, charcoal, metal, or neon tubes, etc.) are used?
- How are they applied (by hand with brushes, or made by machine, for example)?
- What textures result?
- Is the work two-dimensional (flat) or three-dimensional ("in the round")?
- Is it wall mounted or freestanding? Framed or unframed? Does it require a pedestal or does it sit on the floor?
- Does it have any apparent function? (Remember that some art is meant to be used, at least nominally.)

We can't always tell all these things—particularly when looking at reproductions in a book. There may also be aspects of materials and methods that we

don't know. Nevertheless, determining that one work is a medium-size oil painting, framed and mounted on a wall; another is a tiny ceramic bowl; and a third is a large metal, freestanding sculpture immediately sets them apart from one another. Such differences also establish a relationship between their artists and tradition. And, finally, each sets up a different relationship to us.

Robert Rauschenberg's *First Landing Jump* is an excellent example of how collecting data about a work's physical properties gives us a leg up on trying to decipher its cryptic meanings. We can begin by simply listing what we see: Below a large canvas there is a rubber tire sitting on the floor, leaning against the main body of the almost-square painting. Sticking through the tire is a black-and-white painted wooden plank that seems also to insert itself under a black tarpaulin, which is overlaid on the top half of the canvas. Affixed to the tarpaulin is a disk-shaped lamp reflector and some odd metal curlicues. Below is a license plate and a small cloth bag suspended with something heavyish in it. Next to the bag is the top cut from a tin can and a flattened tin can itself. There is also another tin can with a little illuminated light bulb in it. The electrical cord extends out the left side of the painting to a plug somewhere on the wall. Below this, there are the partial remains of a raincoat, glued to the canvas. The canvas seems to be randomly painted, and there is, overall, a rough, messy texture to the painting. The materials generally appear used, tattered, and rusted—the detritus of the streets.

What does this tell us? To begin with, even though Rauschenberg started with a canvas, hung it on the wall, and gave it a few touches with a brush, we can feel fairly certain he was not trying to create a traditional painting. Nor is it quite sculpture. It is

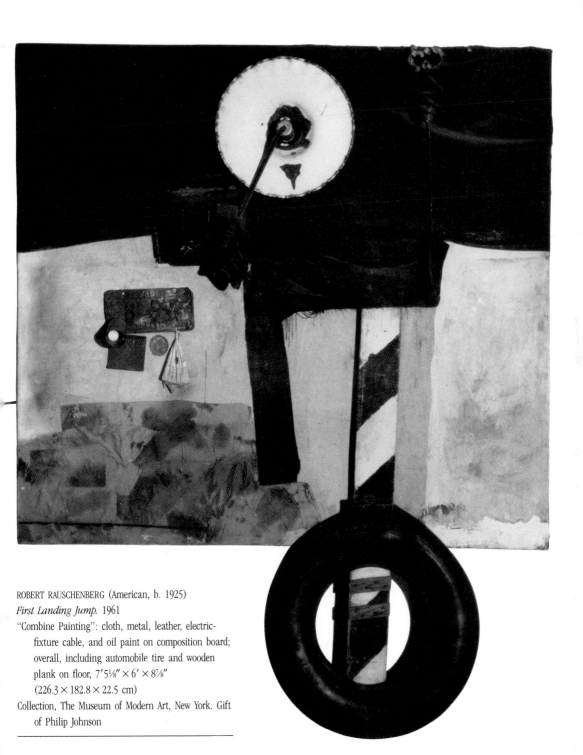

ROBERT RAUSCHENBERG (American, b. 1925)
First Landing Jump. 1961
"Combine Painting": cloth, metal, leather, electric-
 fixture cable, and oil paint on composition board;
 overall, including automobile tire and wooden
 plank on floor, 7′5⅛″ × 6′ × 8⅞″
 (226.3 × 182.8 × 22.5 cm)
Collection, The Museum of Modern Art, New York. Gift
 of Philip Johnson

somewhere between the two, defying categorization. The use of junk—found objects—to create the work seems to indicate further that Rauschenberg does not care about what convention says is important or precious.

The seeming randomness of his choices defies precise, easy-to-read definitions of a subject. For example, although an old nonworking light fixture is included, as is a makeshift tin-can lamp, actually lighted, one is not likely to conclude that the subject is light, particularly not with the powerful black tarpaulin swipe across the top of the canvas—unless, of course, the black represents the sky at night. The lower half of the painting could then be thought to resemble a landmass with horizon and the black a sky with a large round reflecting moon stuck in the center of it.

But these seem to be the only allusions to landscape; the rest of the picture seems more an assemblage of stuff actually found in the world, more city-like than rural in their references. And while landscape paintings usually try to reconstruct a place through visual logic, these found objects seem to set up nonsensical relationships.

Maybe we could look at the painting as being about "the road." The tire, the plank (part of a police roadblock?), the tarpaulin (once a tent?), and the license plate, combined with the landscape allusions, could lead us in that direction. The coat then might represent a person. These "on the road" items are, however, subverted by the little blue light with its attendant electrical cord and the need for an outlet. If we are bumming around or are on a camping trip, we are reminded of the comforts of home or perhaps of some roadside hostel. If we look at the date, we might be reminded of the beatnik era, specifically of Jack Kerouac and his influential book *On the Road.*

Since the painting seems to contain elements of both landscape and trip, perhaps Rauschenberg is merely giving impressions of America, complete with a comment on how we treat the landscape, discarding once-useful objects with abandon. Maybe he is also playing with the conventions of landscape painting as an attempt to make a joke about art history. Or maybe he is looking at the idea of a trip, which is fleeting, like a memory. In any case, it is both amusing and engaging to think about the pun involved in an old enamel lamp reflector representing a full moon on a dark night. The point is that a pile of junk can call up plenty of memories, and therefore the physical properties of a painting can evoke many associations. This associative process goes on whether or not we are aware of it. When we look at a painting of this type, our looking and thinking serve to render this process into consciousness.

Subject

The second observational category is subject matter—what a work is about. Artworks that focus on traditional subjects, such as still lifes, figures, portraits, and landscapes, seem to be discernible statements, even though recognizing objects or people does not necessarily tell us all there is to know about the artwork per se; it just narrows the possibilities. Much modern art is wholly abstract, however, and ferreting out subject matter requires considerable effort. In any case, full readings of subject matter necessitate examination of both the representational and abstract elements included.

In David Alfaro Siqueiros's *Echo of a Scream,* the title tips us off as to Siqueiros's subject. The painting depicts a tiny, screaming figure surrounded by a very

DAVID ALFARO SIQUEIROS (Mexican, 1896–1974)
Echo of a Scream. 1937
Enamel on wood, 48 × 36″ (121.9 × 91.4 cm)
Collection, The Museum of Modern Art, New York. Gift
 of Edward M. M. Warburg

HENRI MATISSE (French, 1869–1954)
The Red Studio. 1911
Oil on canvas, 71¼ × 86¼″ (181 × 219.1 cm)
Collection, The Museum of Modern Art, New York. Mrs.
 Simon Guggenheim Fund

dark and mechanistic world. The open-mouthed, agonized head of the child is repeated—grossly enlarged—directly behind him. This enormous, ominous visage seems to float over a gloomy junkyard or perhaps a battlefield, complete with storage tanks and, on the upper left, an abstracted patch that might represent destroyed nature. The bleak colors of the scene set off the brown child and are cut into by the red of the child's drapery. Muted red also seems to spill over jagged boulders in the foreground, which is strewn with metal and cloth remnants. While the background seems to suggest a "real" world, the farther you move forward, the more abstracted things become. A reasonably clear subject emerges from consideration of title, image, and color—that industrial or maybe military destructiveness reverberates and, unlike echoes, enlarges as it moves out from the source. We are set up to think about repercussions of destruction in global terms, as the state of our environment suggests we must.

Henri Matisse's *The Red Studio* provides a good example of how paintings may have several subjects. We can be reasonably certain that one of these is an artist's work space, probably Matisse's own studio. The painting's title tells us as much, as do such details as the drawing implements on the table, a pile of paintings, and one empty frame in the left corner of the room. So, on the one hand, the subject—a studio—is simply and clearly stated. But let's look further.

Notice the way the sense of space is established. At the lower left one finds a line that indicates where the floor and the wall planes meet. Looking to see where the left and rear walls meet above the painting in the supposed corner, however, we find no such linear indicator. Therefore, if we look only at the top half of the painting, we are given no spatial

definition, a decision that serves to remind us that, regardless of illusions of space, paintings are actually flat. The studio becomes a handy vehicle for both expressing and violating space.

Why is most of the furniture outlined but not filled in, allowing the red walls and floor to show through? We might conclude that another possible subject is the red color itself. Since Matisse in no way varied the red's tonal quality throughout the painting, he gave it unusual weight. He also chose a color that is strong, warm, even aggressive, one often associated with earth or blood and unlikely for any room, particularly a studio, where reflected light would make everything look red, an impossibility for a painter.

Should we read some symbolic notation here? It is tempting to theorize that Matisse, in depicting his studio as blood red, was providing a psychological insight. But if we interpret the intense pressure of the red as an emotional statement, how much further can we go with this? The sweetness of most other aspects of the painting tends to limit such a reading. Moreover, the other paintings set about the room are more conventional, prettier, and safer, and this tends to argue against "the artist's psyche" as a subject of the work.

Given the existence in fairly equal measures of formal (color and space) and expressive (emotional) elements in this painting, perhaps it is this very harmony that is Matisse's focus, his subject.

By eliminating recognizable objects, Franz Kline provides us with a good deal less to start with than either Matisse or Siqueiros did. We therefore deliberate on his subject as we might on certain kinds of poetry—haiku, for example, which uses very few words to open up whole sets of associations and reserves of feelings and sensations without incorporating plot or discernible characters.

VINCENT VAN GOGH (Dutch, 1853–1890)
The Starry Night. 1889
Oil on canvas, 29 × 36¼″
 (73.7 × 92.1 cm)
Collection, The Museum of Modern Art,
 New York. Acquired through the
 Lillie P. Bliss Bequest

A beloved treasure of modern art, this
nightmarish sky — these swirling dashes
of color — above a sleepy village seems to
embody the awe and fear of night to
which most people succumb at one point
or another. Van Gogh's troubled view
and the style with which he describes it
show how abstracting the physical world,
heightening color, and drawing with
choppy stabs of color can amply express
emotional states that are familiar yet
difficult to put into words.

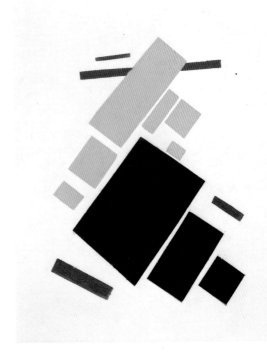

KASIMIR MALEVICH (Russian, 1878–1935)
Suprematist Composition: Airplane Flying. 1915
 (dated on painting 1914)
Oil on canvas, 22⅞ × 19″ (58.1 × 48.3 cm)
Collection, The Museum of Modern Art, New York.
 Purchase

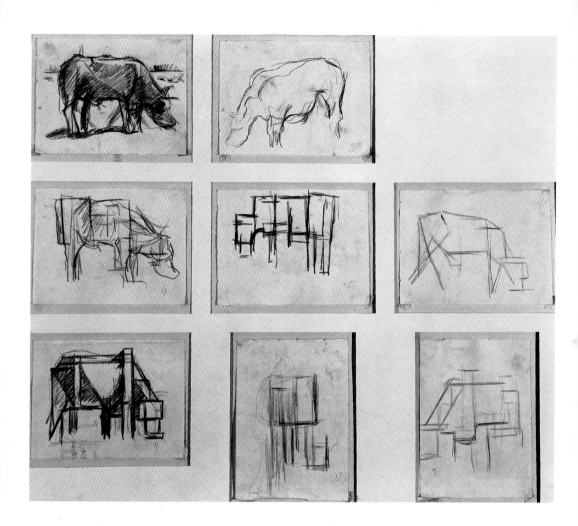

THEO VAN DOESBURG (Dutch, 1883–1931)
The Cow. No date
Series of eight pencil drawings, each 4⅝ × 6¼″
 (11.8 × 17.1 cm)
Collection, The Museum of Modern Art, New York.
 Purchase

in and out, the colors contrast strongly with the background white, and this too creates optical liveliness.

Activated in these various ways, the pieces seem to embody the sense of an object in motion. While no image serves to establish an airplane per se, the play among the various elements creates a dynamic composition that is, for Malevich, an analogy for flight.

LINES

We can continue this breakdown of formal elements by examining the various ways lines are created and how they function in paintings. Even though lines do not exist in nature, they are typically relied upon as the basic units of description in art and are what we ourselves might first lay down on paper if asked to draw something. Most two-dimensional art depends on lines either to establish shapes or to help compose stable pictures through alignments of objects, colors, highlights, or shadows. Art can be rendered out of lines alone; traditional etchings, for example, depend entirely on lines to build up images, some lines delineating shapes, others crosshatched to create areas of light and dark.

Most artistic styles have a way of being realized in line drawings, and there is no limit to the range of possibilities in terms of mood. Line drawing suits the imaginative whimsy of Paul Klee, and of humor in general. Most cartooning is totally dependent on lines for subject, gesture, and expression. Line can also give an impression of eerie, austere beauty, as in Gustav Klimt's *Woman in Profile,* or sensuality, as in Matisse's *Reclining Nude.* Lines can be used to create simple geometric structures, and, in the work of artists such as Bridget Riley (see p. 151), a pattern of lines can produce optical vibrations by their varied thickness and placement.

In another drawing by Matisse, *Girl with Tulips (Jeanne Vaderin),* we can examine the lines to see a record of the artist's working process, the myriad of changes he made as he considered and reconsidered both his subject and his composition.

In most art lines are but one element among others. Roy Lichtenstein's *Drowning Girl* demonstrates how lines work as part of a complex whole. We see that some lines are deliberate and literal, as in the outline of the girl's lips or tears and in the delineations of wave shapes. Other deliberate lines are established by the edges of a canvas, and here Lichtenstein crops his picture in order to emphasize that he shows us only a detail of the story.

Other lines are implied, such as the lines of water we imagine circling out beyond the right side of the canvas, sweeping out one corner and curving back in above the girl's head. Still more lines result from things lining up, such as the axis created by the girl's face bracketed between two puzzle-shaped splashes of water in the lower left and upper right. Another implied line is established by the tops of her fingers in alignment with her eyes and the thought "bubbles." The combination of these two implied lines creates an X that helps lock the composition in place, despite the swirling activity of the water.

André Derain's *London Bridge* shows how lines can also be created where two colors meet, as they do in the strong arcs of the bridge's structure. Another kind of line is created by highlights, so that one can see a line of light reflecting off the water coming toward us from the far shore, or lines of water swirling around the bridge's base. Lines created by the entire shapes of the boats serve as opposing forces to the lines of bridge, traffic, and water high-lights, which, along with the colors, breathe life into this extremely colorful painting of a bustling city.

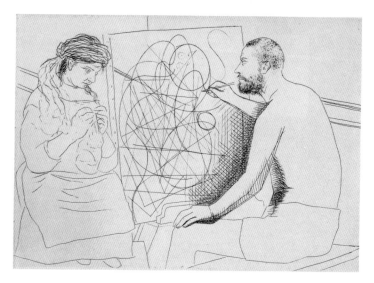

PABLO PICASSO (French, b. Spain,
 1881–1973)
Painter and Model Knitting, plate IV
 from *Le Chef-d'Oeuvre Inconnu,* by
 Honoré de Balzac. 1927 (published
 by Vollard, Paris, 1931)
Etching, 7⁹⁄₁₆ × 10¹⁵⁄₁₆″ (19.3 × 27.8 cm)
The Art Institute of Chicago. Gift of the
 Print and Drawing Club

PAUL KLEE (Swiss, 1879–1940)
Letter Ghost. 1937
Colored paste (mixture of pigment,
 chalk, and starch) on newspaper,
 13 × 19¼″ (33 × 48.9 cm)
Collection, The Museum of Modern Art,
 New York. Purchase

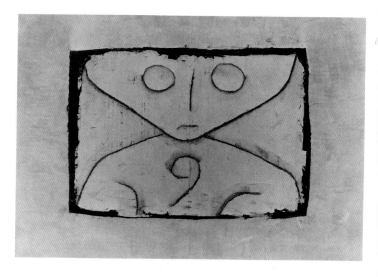

GUSTAV KLIMT (Austrian, 1862–1918)
Woman in Profile. 1898–99
Colored pencil on paper, 16⅞ × 11⅜″ (42.8 × 28.7 cm)
Collection, The Museum of Modern Art, New York. The
 Joan and Lester Avnet Collection

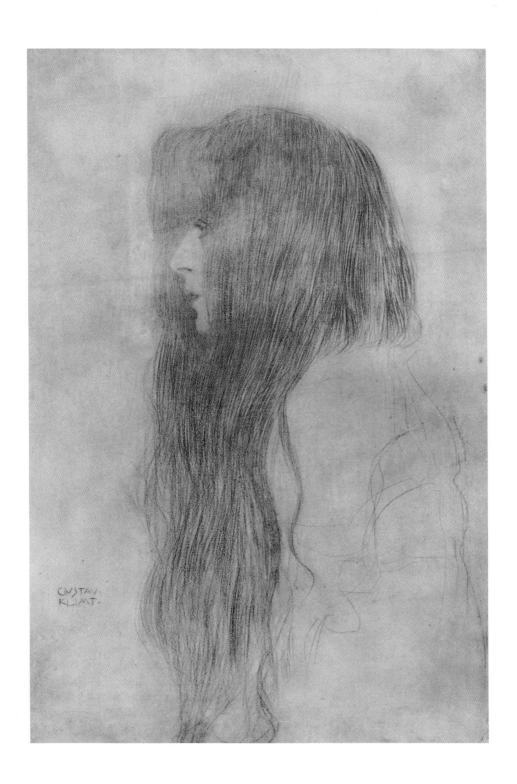

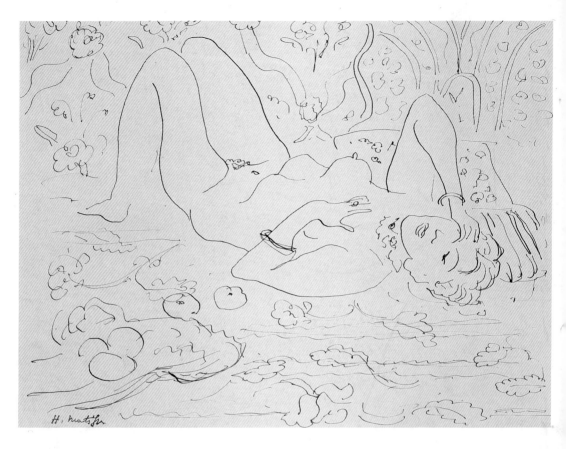

HENRI MATISSE (French, 1869–1954)
Reclining Nude. 1927
Pen and ink on paper, 10⅞ × 15″ (27.7 × 32 cm)
Collection, The Museum of Modern Art, New York. The
 Tisch Foundation, Inc., Fund

HENRI MATISSE (French, 1869–1954)
Girl with Tulips (Jeanne Vaderin). 1910
Charcoal on buff paper, 28¾ × 23″ (73 × 58.4 cm)
Collection, The Museum of Modern Art, New York.
 Acquired through the Lillie P. Bliss Bequest

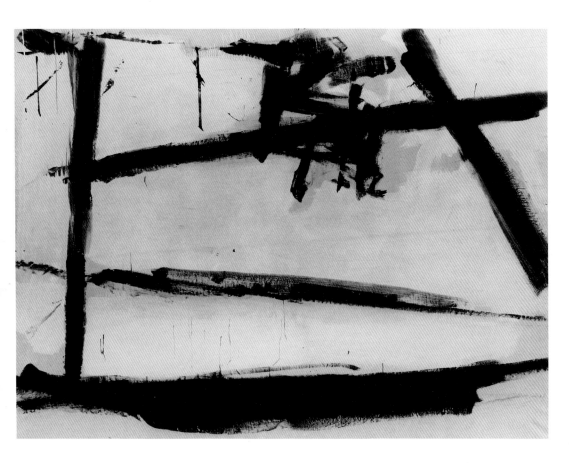

FRANZ KLINE (American, 1910–1962)
Painting Number 2. 1954
Oil on canvas, 6'8½" × 8'9" (204.3 × 271.6 cm)
Collection, The Museum of Modern Art, New York. Mr.
and Mrs. Joseph H. Hazen and Mr. and Mrs.
Francis F. Rosebaum Funds

Even the title of Kline's abstract *Painting Number 2* provides little direction. One way to fathom possible meanings is to start with the expressive content of its physical properties, such as how the proportions of the painting create a sense of horizontal spaciousness reminiscent of a bridge or a landscape. Rotate the painting ninety degrees to see how much it changes. Now it emphasizes upward motion, held in check by lines at top and bottom, perhaps like a window with bars.

When we look at the painting as Kline intended us to, we see stark black bands that span the space the way I-beams connect upright supports in modern skyscrapers. Theoretically, black should recede, but here it does not. Instead, the black seems to sit securely on the painting surface and to suggest structure. If we think of black as solid, therefore, we might at first see the white as emptiness or void. But by looking more closely, we see that the white is varied, that its darker tones tend to recede and the light ones move forward. With several planes thus suggested, we have an illusion of space, as one might find within rooms. Thus, instead of simply suggesting a void, the Cézanne-like manipulation of whites gives them substance, like that of fog, which then fills the room between the black beams. The stark contrast between black and white asserts separate but equal weight. Both are essential units in a powerful, self-contained form as real as a building or a bridge.

Is it possible that strength or power is the subject of this painting? Can we associate this image with architectural stability and with the authority we invest in buildings? Could in fact the irregularity in the "building blocks" suggest the process of a structure erecting itself, still coming together, the drips and the brushiness of the strokes emphasizing growth and progress that we perceive as ongoing?

Could the energy inherent in diagonal lines, especially the one at the right, and the kind of forward-tipping "vehicle" encapsulate the force of cities rebuilding themselves after the war (this was painted in 1954)?

Because Kline lets us see the work of his hand, we can observe the literal strokes of his large, house-painting brushes and even determine their order. By observing what is laid on top of what, we are privy to his process, some of his thinking/acting. In this way, the work can be seen as autobiographical. If Matisse stops us from psychological interpretation after a certain point, Kline seems to invite us to conclude that his meanings can be seen as both personal and general.

More like Matisse, Piet Mondrian was not anxious to let us see or know much about himself in the images he painted. While Siqueiros made a passionate statement about the human condition and Kline incorporated the force of his gesture as an element of meaning, Mondrian quietly composed an orderly and balanced world.

The painting illustrated here is entitled *Composition,* which tips us off to what aspect of the painting most concerns Mondrian. And the subject may be as simple as that: how to compose or organize color and lines within a rectangle. The artist restricts color choices to red and blue (he also used the third primary color, yellow, in most of his compositions done at this time), plus black and white. He uses only vertical and horizontal lines, eliminating diagonals that might imply movement or otherwise activate the careful, quiet balance.

The pleasure to be gained in Mondrian's work is in looking for subtleties, such as the fact that his organizational principle is a grid; however, while this grid is precise, it is not completely regular. The width of the lines is irregular also, which one can

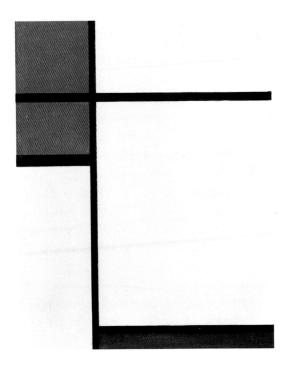

PIET MONDRIAN (Dutch, 1872–1944)
Composition. 1933
Oil on canvas, 16¼ × 13⅛″ (41.2 × 33.3 cm)
Collection, The Museum of Modern Art, New York. The
Sidney and Harriet Janis Collection

see by comparing them carefully. The various combinations of colors react differently to each other. For example, the blue and the black tend to blur into one another while black and red stand in a warm, intimate contrast; the white and black set each other off absolutely. Consider the decisions Mondrian had to make regarding color and size of the blue-black box in order to give the painting a foundation strong enough to anchor the bright, decidedly off-center red blocks that might otherwise tip the whole composition to the left.

Mondrian's painstaking process is one of seeing how each element of color, line, and proportion relates to others and to the whole, and how they operate on our eyes to effect a dynamic, asymmetrical balance. Mondrian's subject involves a careful plotting of precisely what exists in front of us and is perhaps a metaphor for the search for perfection.

Illusionary Properties

The term *illusion* is used in both painting and magic because the two mediums frequently share a goal: to fool our eyes, making us believe in something that is not literally possible.

In the next section of this chapter, we shall discuss properties of color that can create illusions of motion and shifting planes. We shall also look at the sensation of three-dimensional form created by using shadows, shading, and highlights. Here we shall examine additional methods of manipulating space, which modern artists often use in ways that contradict each other and their traditional purposes.

The several spatial "magic tricks" include very familiar devices: overlapping to make one thing appear to be in front of or behind others; reducing the size of things intended to be seen as farther away (called scale perspective); decreasing detail and softening the focus to make distant things seem less distinct (atmospheric perspective); and, finally, emphasizing depth by using linear devices (called variously geometric or linear perspective) commonly illustrated by train tracks that seem to converge as they recede into the distance. There are various schemes for establishing believable linear perspective, but what is often called one-point perspective (the train-track effect) is well illustrated by Vincent van

VINCENT VAN GOGH (Dutch, 1853–1890)
Hospital Corridor at Saint-Rémy. 1889
Gouache and watercolor on paper, 24⅛ × 18⅝″
 (61.3 × 47.3 cm)
Collection, The Museum of Modern Art, New York. Abby
 Aldrich Rockefeller Bequest

Gogh's drawing of a corridor in a hospital in France. The gradual lessening of detail, also apparent here, enhances the sense that the corridor leads off to distant parts of the building. The effect of this is somewhat ominous, particularly given the figure disappearing into a very sketchy, ghostlike door and the overall darkness of the hall. The light at the end of the tunnel is more frightening than reassuring, an indication that even such academic devices as

linear perspective can bring expressive meaning to a work.

It is perhaps a form of tribute to past virtuosity that modern artists often either avoid or subvert the tools most likely to create these illusions. Given a history in which painters learned to use these tools impeccably, modern artists often do not feel compelled to continue in that tradition. When contemporary artists resort to highly realistic representation, it often refers to or imitates developments in photography, film, and video, the very existence of which, paradoxically, helps explain why so many artists sidestep the issue of illusion altogether.

A typical twentieth-century approach to the tools of perspective is apparent in the painting by Giorgio de Chirico entitled *Gare Montparnasse (The Melancholy of Departure)*. In this painting De Chirico subverts our expectations, not only by supplying us with bananas that seem too big and people who seem too small by comparison to their surroundings, but also by an inconsistent use of linear perspective; if the arcade diminishes in size as it recedes to a point on the horizon where it vanishes, so should the walk beside it. Moreover, at the vanishing point it should not be possible to make out a train; it too would vanish.

Playing with space is not the only subversive act in this image. The manipulation of light is a device deployed in this painting, as it generally is in theater, in order to make us believe in the context. For example, there is the illusion of a strong light source whose angle and strength are implied by the shadows. The angle of the implied sun, however, is not consistent with the twilight look of the sky, an illusion effected by the way colors are blended into one another (light at the horizon, moving upward to very dark, as they are at sunrise or sunset). And

speaking of time, if the sunlight and shadows imply late afternoon and the horizon twilight, then the time on the clock face makes no sense.

The clock, the pennants, the train, and so forth all contribute to creating the illusion of a familiar context and are incorporated to add further to the story of this place and time. But the wind that keeps the pennants flapping—an illusion we register because of the wavy lines with which the flags are rendered—does not seem to be affecting the train's steam, and the logical story is again subverted.

As noted above, by being quite specific about time, given clocks and qualities of light, De Chirico seems to create an image in which timelessness, perhaps even eternity, are at issue. Similarly, he clearly presents trains, people, and architecture in such a way as to take away specific identity, as if to use the particular as a metaphor for the general—thus, Gare Montparnasse becomes a symbol of the feeling of all "good-byes."

Formal Properties

A fourth category of observation focuses on line, color, and shape and on how these so-called formal elements are arranged to create compositions.

Some modern paintings emphasize formal elements almost exclusively. We saw this with Kline and Mondrian, but abstract painters are not the only ones who depend on these tools to create meaning. Van Gogh painted short strokes of color to build up recognizable images, and his choppy, staccato stroke is part of why his paintings are so emotionally volatile. (Look back at *Hospital Corridor at Saint-Rémy* to consider this.) In *The Starry Night,* his combination of strong, often unlikely colors and broken lines outweighs the subject as the vehicle of expressiveness.

Just how integrally many modern artists believe in the language of geometry can be seen in a progression of studies by Theo van Doesburg for a painting, *The Cow*. He examines the cow by drawing it, simplifying it, and geometricizing it. Eventually, he reduces its form to mass, perhaps as both a visual and metaphorical representation of the cow's solidity and stolidness.

Kasimir Malevich provides another example of a typical modernist, reducing painting to a presentation of color, shape, and line in his *Suprematist Composition: Airplane Flying*. This image consists only of rectangles of black, blue, yellow, and red, a few of the latter so elongated that they become lines. The sizes of the rectangles are irregular, as is their placement. The colorful shapes tilt somewhat uneasily in the middle of a field of white, and this diagonal orientation itself establishes a feeling of motion that contrasts with horizontal and vertical forms.

Expanding on the diagonal as a source of motion, Malevich discovered that one can produce either a sense of stasis or agitation by deciding whether two shapes touch, almost touch, or keep their distance from one another. If you look at the different spacings in this work, you will see those placed very close together almost flutter because of their proximity.

Color can also be used to simulate movement. Given its property of equating to deep shadow and dark spaces, black can seem to create holes in the canvas. By contrast, the blue blocks seem less far back in space. The bright yellow, glowing like a light source, seems to push out from the canvas, riding an easy distance in front of the red, which cuts back behind it. In addition to this pulsating

GIORGIO DE CHIRICO (Italian, b. Greece, 1888–1978)
Gare Montparnasse (The Melancholy of Departure).
 1914
Oil on canvas, 55⅛ × 72⅝″ (140 × 184.5 cm)
Collection, The Museum of Modern Art, New York. Gift
 of James Thrall Soby

ROY LICHTENSTEIN (American, b. 1923)
Drowning Girl. 1963
Oil and synthetic polymer paint on canvas,
 67⅝ × 66¾″ (171.6 × 169.5 cm)
Collection, The Museum of Modern Art, New York.
 Philip Johnson Fund and gift of Mr. and Mrs.
 Bagley Wright

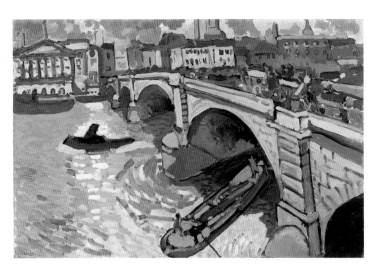

ANDRÉ DERAIN (French, 1880–1954)
London Bridge. 1906
Oil on canvas, 26 × 39″ (66 × 99.1 cm)
Collection, The Museum of Modern Art,
 New York. Gift of Mr. and Mrs.
 Charles Zadok

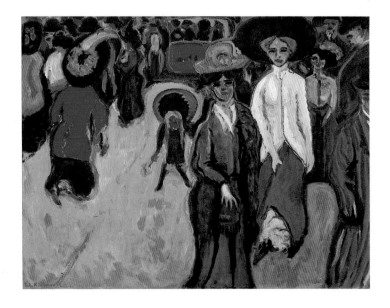

ERNST LUDWIG KIRCHNER (German, 1880–1938)
Street, Dresden. 1908 (dated on painting 1907)
Oil on canvas, 59¼ × 78⅞″ (150.5 × 200.4 cm)
Collection, The Museum of Modern Art, New York.
 Purchase

COLORS

Colors also have specific ways of functioning in paintings. They can provide such contrasting properties as beauty, serenity, vitality, as well as producing optical effects, personal associations, and symbolic meanings.

One conventional function of color is the way it is used to refer to a color we know in nature—green leaves, for example. Colors can also be used to exaggerate a natural phenomenon, even making something become grotesque. This is one of the characteristics of Expressionism, a term applied to the work of artists who push the parameters of color to find in it a language of emotion and excitement. (See the chapter "Useful Vocabulary" for brief definitions of major art terms.) *Street, Dresden* by Ernst Ludwig Kirchner demonstrates how lurid colors can distort or transform a fairly ordinary street full of fashionable bourgeoisie in 1907 into an intense world of masked zombies.

A more playful use of color is apparent in a drawing by André Derain, *Bacchic Dance,* showing three nudes in a pastoral setting. Two reclining figures are languidly drawn with light pencil lines. The third is painted red, serving to activate the figure and emphasizing the sexuality of her dance. With the intent to convey sensory impressions rather than strict realistic rendering, Derain defines intense light and the sun itself by a bright yellow. Blue reads as both sky and water and, for whatever reason, a tree. A watery green suggests grass and leaves.

Vasily Kandinsky wrote a great deal about color and its effects, and in *Murnau Landscape* he uses them to intensify sunlight at the beginning or end of a spectacular day in the mountains. This Technicolor rendition tends to have the effect of heightened experience, analogous to the distorted reality of fairy tales. It was not an enormous leap for him to let go of any specific references to the physical world, and we can see that in his abstract paintings he maintains an organic distribution of colors so that, instead of being about nature, his canvases seem charged with natural energy—such as one senses at the coming of a new season, as he demonstrates in his *Painting Number 201.*

Another modern artist known for luxuriant color is Henri Matisse. It is exciting to experience the impact of the great fields of color he provides in huge canvases, such as *Dance.* In addition to suggesting sky or water, grass, and white skin tones, his strong, deep colors seem to extend out into the space around them, enveloping the viewer (which is somewhat hard to appreciate in a reproduction) and making one feel the painting as much as see it. The color draws us in by its richness and vibrancy, and, once drawn in, we begin to observe the quirkiness of his line and his brushwork. Interestingly, Matisse chose colors naturalistically, but in his paintings they are used in such a concentrated way and in such large doses that we tend to see them as colors more than as representative of sky or water, grass or light flesh tones. The colors help to convert this folk dance into an emblem of all dance. They ask us to wonder about the cryptic, primal ritual and the lush nudes engaged in it.

Optical and perceptual effects of color have themselves become the focus of much art. Georges Seurat's famous experiments in which he daubed dots of colors onto canvas brought to Post-Impressionist painting a scientist's concern with the phenomenology of vision. Informed by color theories and by new discoveries about how our eyes work, Seurat decided that painting could rationalize and perhaps even explain reality, and thus he painted points of color that theoretically mix with one another in the

viewer's eyes. Up close, the paintings are completely different from the way they seem at a distance.

Hans Hofmann's abstract paintings were among the first to explore the "push and pull" of colors, as he put it. Recognizing the tendency of darker colors to appear to recede and lighter ones to project, Hofmann experimented with blocks of color arranged to interact with one another. He was very deliberate, if not fastidious, which one can see from looking closely at the various layers of color. He apparently experimented to create juxtapositions that would imply spatial contradictions. Therefore, if we look at the top third of *Cathedral,* we see an orange-red block on the upper left and bits of the same orange-red peeking out here and there in the interstices between other color blocks. Each time this orange-red appears, our eyes read a plane—let's say it is even with the canvas's surface. Compare the orange-red plane to those of every color it touches, and observe the shifts relative to it. Some colors seem to recede behind it while others float in front of it, making the same orange-red seem to shift planes as well.

Let your eyes remain on different parts of this painting for a while and notice the vibrating operation that starts to occur. We see that the tendencies of light and dark to project and recede are indeed only tendencies. Depending on their immediate context, they behave in an unpredictable tug-of-war, different for each of us. It is these ambiguities that interested Hofmann and, of course, that provide interest for the viewer.

SHAPES AND FORMS

Both lines and colors are integral to creating shapes and vice versa, and therefore the overlap is great enough that at some points it seems specious to separate them. The purpose of this exercise, however, is to stimulate careful looking so that we notice more. Therefore, we shall explore shapes in isolation.

In this text, the word *shape* is used to designate flat figures or outlines and *form* to mean shapes that have been modeled or rendered as if three-dimensional or existing in space. *Form* was also mentioned in the "Illusionary Properties" section of this chapter, but it seems important to note here that an artist uses several devices with which to achieve a sense of form, among them modeling an object as if light were cast on it—highlighting some surfaces, shading others, and creating shadows—called *chiaroscuro,* the Italian word for light and shadow.

There is a whole vein of work in the twentieth century that focuses on varying arrangements and changing relationships of geometric shapes and forms for both its subject and content. How is an image changed by altering colors or sizes (as Hofmann did)? What happens when you repeat a shape or pattern, perhaps over and over? Some artists are sufficiently interested in such issues that they spend entire careers working within very narrow problem-solving frameworks.

A typical example is Kasimir Malevich, whose work sought artistic purity expressive of the utopian goals of the Bolshevik revolution, with which he was in sympathy and aligned by a parallel theory. The two drawings illustrated here address the subtle visual effects of forms located differently within identical rectangles set within rectangular paper sheets. Malevich establishes a sense of motion or stability within a carefully controlled environment by exploring symmetry and its relationship to balance. He also maximizes delicate variations in surface textures by drawing lightly with pencils, using varying densities of gray to further enliven the quiet compositions.

ANDRÉ DERAIN (French, 1880–1954)
Bacchic Dance. 1906
Watercolor and pencil on paper,
 19½ × 25½″ (49.5 × 64.8 cm)
Collection, The Museum of Modern Art,
 New York. Gift of Abby Aldrich
 Rockefeller

VASILY KANDINSKY (Russian, 1866–1944)
Murnau Landscape. 1908
Oil on paper, 27¼ × 37″ (69.2 × 93.9 cm)
Collection, The Museum of Modern Art,
 New York. Promised gift of an
 anonymous donor

VASILY KANDINSKY (Russian, 1866–1944)
Painting Number 201. 1914
Oil on canvas, 64¼ × 48¼″ (163 × 123.6 cm)
Collection, The Museum of Modern Art, New York.
 Nelson A. Rockefeller Fund (by exchange)

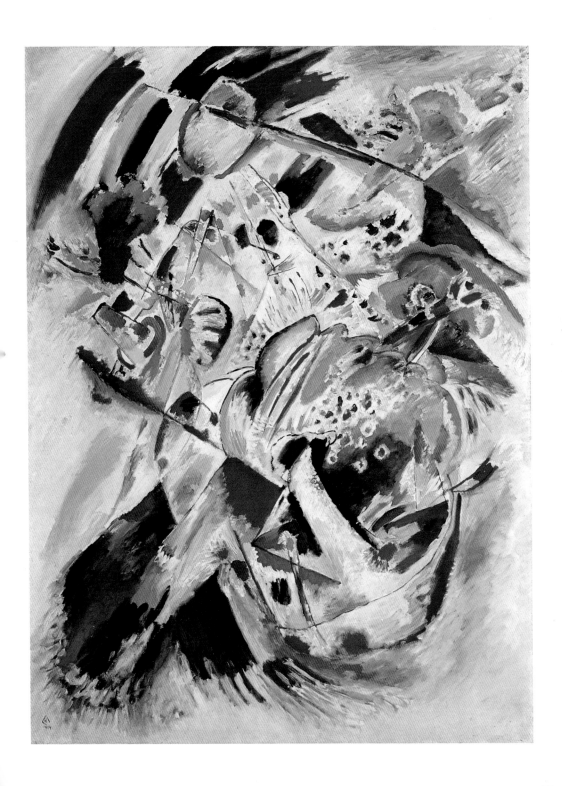

KASIMIR MALEVICH (Russian, 1878–1935)
Suprematist Elements: Circle. 1915
Pencil on paper, 18½ × 14⅜″ (47 × 36.5 cm)
Collection, The Museum of Modern Art, New York

KASIMIR MALEVICH (Russian, 1878–1935)
Suprematist Elements: Squares. 1915
Pencil on paper, 19¾ × 14¼″ (50.2 × 35.8 cm)
Collection, The Museum of Modern Art, New York

EL LISSITZKY (Russian, 1890–1941)
Proun GK. c. 1922–23
Gouache, brush and ink, and pencil on paper,
25⅞ × 19¾″ (65.6 × 50 cm)
Collection, The Museum of Modern Art, New York

57

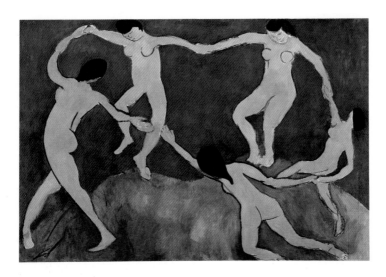

HENRI MATISSE (French, 1869–1954)
Dance (first version). 1909
Oil on canvas, 8′6½″ × 12′9½″
 (259.7 × 390.1 cm)
Collection, The Museum of Modern Art,
 New York. Gift of Nelson A.
 Rockefeller in honor of Alfred H.
 Barr, Jr.

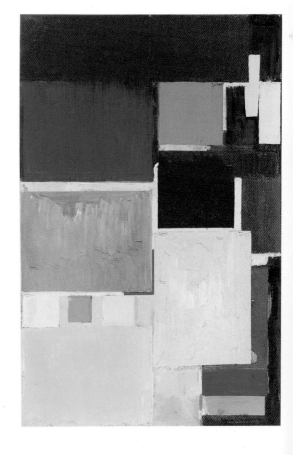

HANS HOFMANN (American, b. Germany, 1880–1966)
Cathedral. 1959
Oil on canvas, 74¼ × 48¼″ (188.5 × 123.9 cm)
Collection, The Museum of Modern Art, New York.
 Promised gift of an anonymous donor

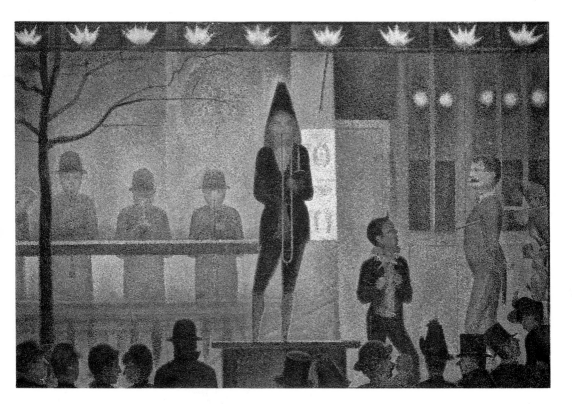

GEORGES PIERRE SEURAT (French, 1859–1891)
Invitation to the Sideshow (La Parade). 1887–88
Oil on canvas, 39¼ × 59″ (99.7 × 149.9 cm)
The Metropolitan Museum of Art. Bequest of Stephen
 C. Clark, 1960

The drawing *Proun GK,* by another Russian, El Lissitzky, enlarges these concerns somewhat by using different colors and gradation of tones as well as a more complicated arrangement of shapes. Some of the geometric shapes are drawn to conform to principles of perspective, which gives them the sensation of having bulk. He also quietly mottles the paper's surface to give the background an atmosphere that enhances the sense of space.

In a way typical of modernists, Cubist Juan Gris uses form-giving light and shadow in the still life *Fruit Dish and Bottle.* A shaft of light seems to fall from the upper left, lighting parts of the bottle and the bowl as well as the table beneath. A deep shadow is created to the right side of the bowl, and its stem and underside are shaded to contrast with the brightly lighted upper surfaces. But no consistent logic applies. Gris plays with conventions, upsetting the logical arrangements of planes and consequently dislocating shaded areas. Much Cubist art makes little attempt to use illusionistic devices, but for Gris the playfulness of creating expectations and subverting them adds irony to an otherwise analytic exercise.

Sculptor Constantin Brancusi focused on shapes to capture sensations, which he further enhanced by his choices of material and surface finishes. His famous *Bird in Space* arcs gently upward, a smooth, sleek, elegant projectile reminding us of the gesture of a flying bird. The gleaming, reflective surfaces catch light, evoking a weightless feeling of flight.

Fernand Léger found a visual language to celebrate his enthusiasm for what has been called, in the aftermath of World War I, the "machine age." The mechanistic yet glamorous women in *Three Women (Le Grand Déjeuner)* are set in a room decorated with shapes and patterns that could refer to the decorative motifs of the Art Deco style, which

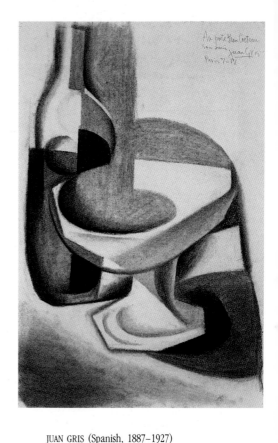

JUAN GRIS (Spanish, 1887–1927)
Fruit Dish and Bottle. 1917
Conte crayon and crayon on paper, 18¾ × 12¼″
 (47.6 × 31.1 cm)
Collection, The Museum of Modern Art, New York.
 Acquired through the Lillie P. Bliss Bequest

CONSTANTIN BRANCUSI (French, b. Romania,
 1876–1957)
Bird in Space. 1940
Polished bronze, height 53⅜″ (135.6 cm)
Peggy Guggenheim Collection, Venice, The Solomon R.
 Guggenheim Foundation, New York

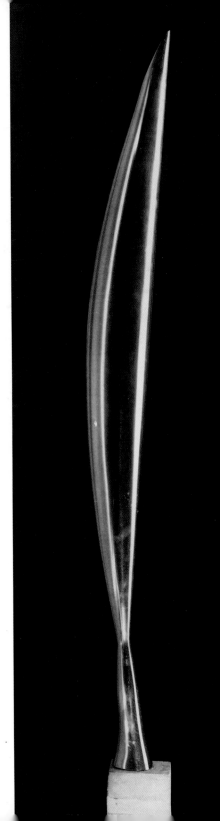

itself also glorified modern technological possibilities. Or they could bring to mind patterns in the decorative arts of tribal peoples. In either case, Léger's attitude toward his civilization, whether all modern or indeed the amalgam of new and old, machine- and handmade, mechanistic and sensual, is conveyed to us by way of geometric shapes and forms.

COMPOSITION

The final formal property that we want to isolate is composition. It is useful to think of composition in architectural terms because much painting and sculpture in the Western tradition began basically as architectural arts: they were designed to fit spaces and perform functions in relation to architecture. Perhaps the logical organization required of architectural structure has forever dictated that painting and sculpture would follow its conventions.

In any case, composition provides the artist with the logic within which to organize a work. It is much like a skeleton. While we rely on appearance to recognize someone, the outward gesture depends on a functioning network of bones to look the way it does and to operate in the world. The composition is, therefore, essential. If the compositional structure works on the eye, the artist is provided with a base that allows experimentation and randomness in other aspects of a work.

There are few artists who felt more keenly about the need for strong composition than Paul Cézanne. We can see his concerns worked out in *Still Life with Apples,* as we can with virtually any of his paintings. To begin with, look for lines that divide the painting both horizontally and vertically. Here, a horizontal line begins with the back edge of the table on the right and, moving leftward, is continued by the base of the bowl and the blunt point of the white cloth,

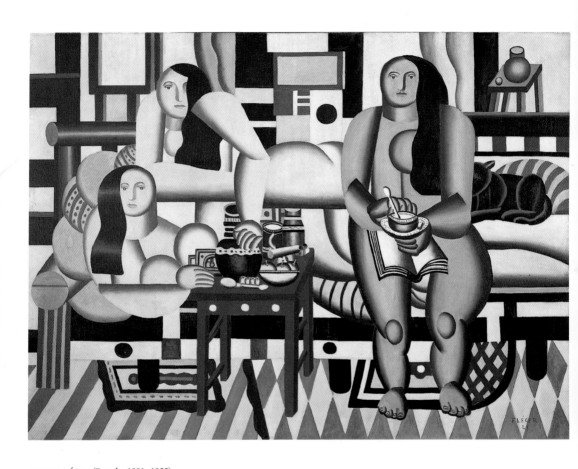

FERNAND LÉGER (French, 1881–1955)
Three Women (Le Grand Déjeuner). 1921
Oil on canvas, 72¼ × 99″ (183.5 × 251.5 cm)
Collection, The Museum of Modern Art, New York. Mrs.
 Simon Guggenheim Fund

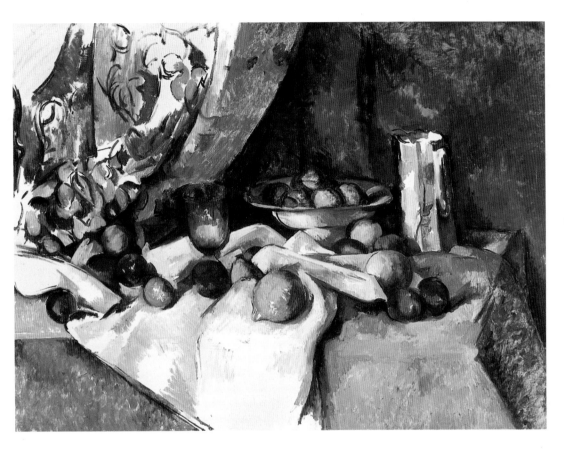

PAUL CÉZANNE (French, 1839–1906)
Still Life with Apples. 1895–98
Oil on canvas, 27 × 36½″ (68.6 × 92.7 cm)
Collection, The Museum of Modern Art, New York.
Lillie P. Bliss Collection

then implied within the deep shadow, and finally picked up by the partly unpainted patterns of the curtain fabric. The vertical axis is perhaps more subtle, but, beginning with the focal lemon, we can work both up and down to find a wide line—partly indicated by darkened shadows above and the fold of the tablecloth below.

Moving on to other structural elements, we see that a series of blocks runs across the lower fourth of the painting, like a subliminal foundation, discernible in drawn or implied vertical lines in the cloth surface as it hangs from the front edge of the table. Meanwhile, the upper left quadrant of the painting is virtually contained within a quarter circle drawn by the curtain's shape.

The fruit is arranged so that most of it falls within a triangle that might be saying by its central position, This is where you should focus, were it not for the competing, dramatic curtain, the brilliant white of the cloth, and the strength of the visual pull of the vase.

We can find other geometric subdivisions if we pursue this examination further. The point is that, given a basic structure, Cézanne provides himself with firm boundaries that enable him to otherwise confuse us spatially, to leave parts of the painting unfinished, and to experiment with contradictory relationships.

Viewer Perspectives

This final category of observation requires that we determine where the artist positions us, the viewers, with regard to the work of art. For example, Henri de Toulouse-Lautrec puts us on intimate terms with a popular and scandalous nightclub dancer of his day, La Goulue ("The Glutton," who eventually ate her way to grossness), bringing her right up next to us by cropping out her legs and roughly half of the bodies of each of her companions. This intimacy increases the insouciance of her gaze, directed away from us despite our proximity directly in front of her. It appears we can be nearby but not close to her. The abruptness of this unwarm intimacy may be titillating, but it is disconcerting and perhaps describes Toulouse-Lautrec's own relationship to the entertainer and her milieu.

If Toulouse-Lautrec wanted to imbue our experience with psychological overtones, it is equally easy for an artist to set up a circumstance that is completely dispassionate. In *American Landscape* Charles Sheeler places us above a scene, perhaps on a ladder like the one in the lower right corner, looking over a fence toward a pristine but bleak factory. While it is not a totally objective bird's-eye view, we are nevertheless outsiders looking into a place where we find no evidence of human activity. This distancing, enhanced by a detailed rendering of the impeccable work site, might lead us to look at the still, coldly beautiful industrial complex as sculpture.

Many other works, especially sculpture, literally manipulate our movement. We either must walk around, through, or occasionally over them in order to fully see and experience them. We must stand up close and also at some distance in order to see all that is happening. Large paintings insist on this as much as sculpture does. The way that this physical manipulation challenges our perception is dramatically demonstrated by a freestanding glass construction by Marcel Duchamp, the title of which is more an instruction than it is a name: *To Be Looked At (From the Other Side of the Glass) with One Eye, Close To, for Almost an Hour.*

We have to start thinking about these directions

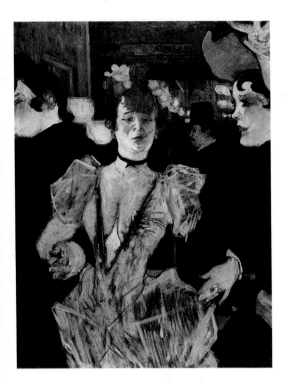

HENRI DE TOULOUSE-LAUTREC (French, 1864–1901)
La Goulue at the Moulin Rouge. 1891–92
Oil on cardboard, 31¼ × 23¼″ (79.4 × 59 cm)
Collection, The Museum of Modern Art, New York. Gift
of Mrs. David M. Levy

as soon as we read them. Which is the "other" side of the glass, for example? How close is "close," particularly if we see this object in a museum? If we are looking "at" it, what about "through" it, which seems inevitable, especially if by any chance we keep looking for an hour. One-eyed looking changes what we see drastically and is actually difficult for even a short period, much less an hour. As a consequence, even imagining the instructions sets up a new relationship to the object and its perception. Typically, people spend mere seconds looking at objects in museums. We might deplore this fact, but spending longer requires altering behavior, and perhaps this is part of Duchamp's point. What if we actually try some form of this exercise while looking at something else—another artwork, a storefront display window, or even television?

In any case, our personal space, behavior, and rights in general are in some measure encroached upon by this work and its authoritarian title, itself a parody of titles in the way it tells us to do something rather than providing clues as to the artist's intentions. In one form or another, many works of twentieth-century art similarly manipulate us. From the questions raised by Cézanne to the physical barrier provided by Richard Serra's *Tilted Arc* (p. 9), we see time and again that we are asked to define our relationship to a work in very personal terms.

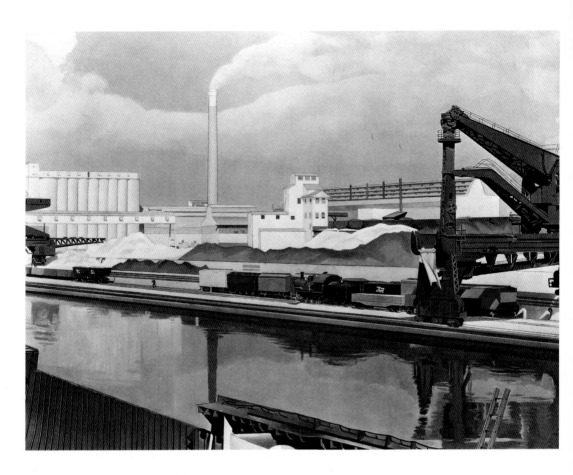

CHARLES SHEELER (American, 1883–1965)
American Landscape. 1930
Oil on canvas, 24 × 31″ (61 × 78.8 cm)
Collection, The Museum of Modern Art, New York. Gift
 of Abby Aldrich Rockefeller

MARCEL DUCHAMP (French, 1887–1968)
To Be Looked At (From the Other Side of the Glass) with
 One Eye, Close To, for Almost an Hour. 1918
Oil paint, silver leaf, lead wire, and magnifying lens
 on glass (cracked), 19½ × 15⅝″ (49.5 × 39.7 cm);
 mounted between two panes of glass in a standing
 metal frame 20⅛ × 16¼ × 1½″ (51 × 41.2 × 3.7
 cm); on painted wood base, 1⅞ × 17⅞ × 4½″
 (4.8 × 45.3 × 11.4 cm); overall height 22″
 (55.8 cm)
Collection, The Museum of Modern Art, New York.
 Katherine S. Dreier Bequest

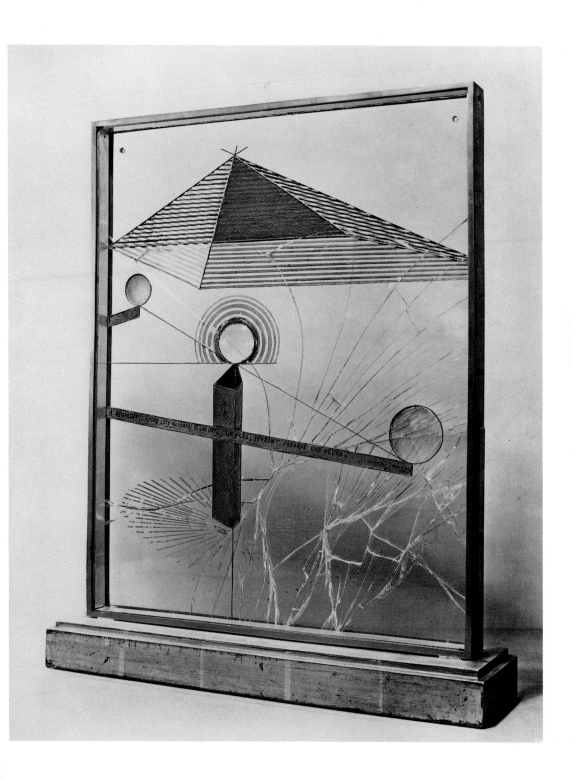

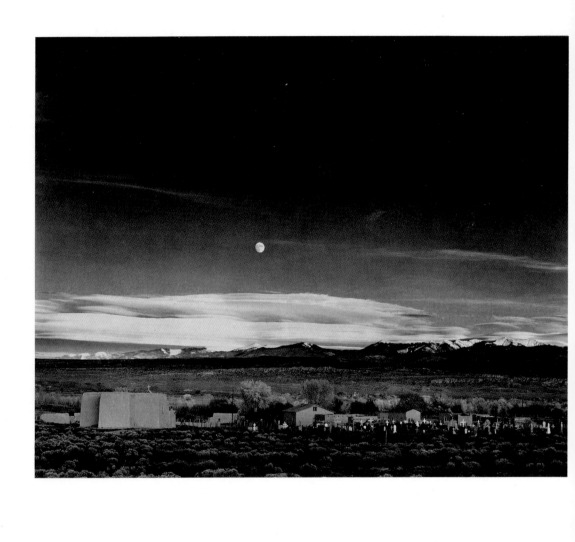

ARTISTIC MOTIVATIONS:

Further Notes on
Why Artists
Do What They Do

Photographer Ansel Adams built on the traditions of painted landscapes but showed that the camera—even when dependent on black-and-white film—could reveal mysterious beauties that painting never had. As used by Adams, photography can indeed document a place, thus providing useful data. Even more, it can inspire us and shape our experience of looking and thinking about a place, uniquely framing a scene and capturing a perfect configuration of subject and light. The potential to record, as well as to transform, has made photography a critical tool of art and provided whole new ways of representing and probing the physical world.

Thus far in this book, we have taken a quick look at how change in the twentieth century has affected art-making, altering it irrevocably. We have also dwelt on ways of observing art in order to glean meaning from it. At this point, it seems appropriate to look more deeply at specific motivating factors that affect artists and the way they work.

A factor that has all but preoccupied modern artists is the desire to represent unconscious states of mind, and both recognizable imagery and abstraction have been employed to do this. Beauty and decoration are still motivating factors in the work of many artists. Awareness of history, too, is an inspiration: some artists react against both the immediate and distant past and others adopt and adapt it. Other artists choose subjects and mediums because of social and political concerns they wish to address. Humor and irony play a motivating role, also, and we shall see that iconoclasm—the desire to invent, subvert, and even trivialize—greatly motivates artistic choices. Finally, we shall note that the very factors that excite some—the existence of advertising media, for example—offend others, creating an amazing diversity of expressions, all reflective of the culture that produced them.

We shall first consider various reasons for depicting recognizable imagery. Some of these reasons relate to photography and its tremendous presence. Others capitalize on the ability of realistic elements to suggest narratives or encourage personal associations.

Some modern artists have created breathtakingly believable facsimiles of physical reality. In both painting and sculpture, we have seen extensions of earlier—very high—standards of proficiency as artists have become more and more accomplished at fooling the eye. Some of these efforts make use of photography as a technical tool. Others capitalize on

the conventions of photography to which we have become accustomed, so accustomed, perhaps, that we may not even be aware of photography as their source.

The invention of photography in the nineteenth century was looked upon by many as a threat to painting, and, in fact, photography's capacity to record, interpret, and persuade has indeed profoundly changed and added to our visual world. Regardless of whether or not the camera can lie, its capacity to document aspects of the real world reduces the urgency with which painters need to try. Besides depicting scenes of daily life, distant places, and wonders of the world, photography has substantially replaced portrait painting. But more important than what it has displaced is what it has added.

Photographic technology has unleashed by now millions of images, each of which potentially suggests a new and unique way of seeing something. The ease of taking photographs has opened up choices with regard to subjects in general as well as to what the photographer encloses within a frame. Photography has given us the "close-up," which has increased our attention to minute detail, and it has made black-and-white images acceptable representations of reality. Cameras have also made possible spontaneous images, candid and of a particular moment.

They have trained us to see in some specific, even peculiar ways. For example, most cameras have a single lens (comparable to having one eye), and therefore photographs tend to decrease the sense of three-dimensionality induced by binocular vision, and we have become used to flattened images. Also, cameras normally fix on one plane of focus (for example, the facade of a building, not what is inside a window), whereas most earlier art created the illusion of a deeper field of focus.

Photographs make use of a wide range of lighting possibilities, some very dramatic and staged, some completely natural, and others wholly artificial — think of the overlit effect of flashbulbs on surfaces and the limited focal range illuminated by such stroboscopic light.

One response to photography in painting is exemplified by *Susan,* an enormous black-and-white portrait by Chuck Close, who is known as a Photorealist, an artist whose style of realism depends on photography. Close reproduces close-up head shots of casual, banal poses, providing an unflattering intimacy with skin and hair, dramatized by magnification. Only the foremost part of this image is in perfect focus, with everything else losing clarity, and the image generally has the washed-out effect of a flash photograph's cold and overbright illumination.

If we look very closely at the surface, we see a tiny grid pattern, filled in with darker and lighter dots — an ironic play on the work of the painter Georges Seurat, who dealt with color perception with dots of paint placed closely together. From this we might surmise that Close's working process involves

NEIL WINOKUR (American, b. 1945)
Collins & Milazzo. 1988
Cibachrome, $54 \times 48''$ (137.2×121.9 cm)
Courtesy of Barbara Toll Fine Arts, New York

Just as Ansel Adams showed how photography can heighten our perceptions and increase our sensitivity to environment, Winokur uses photography to poke fun at the stuffiness of much portraiture, whether painted or photographed. Formal poses, draperies, and lush surroundings that include the most valued treasures of the sitters — all traditions within portraiture — are seen with ironic freshness because of the hyper color and general air of artificiality.

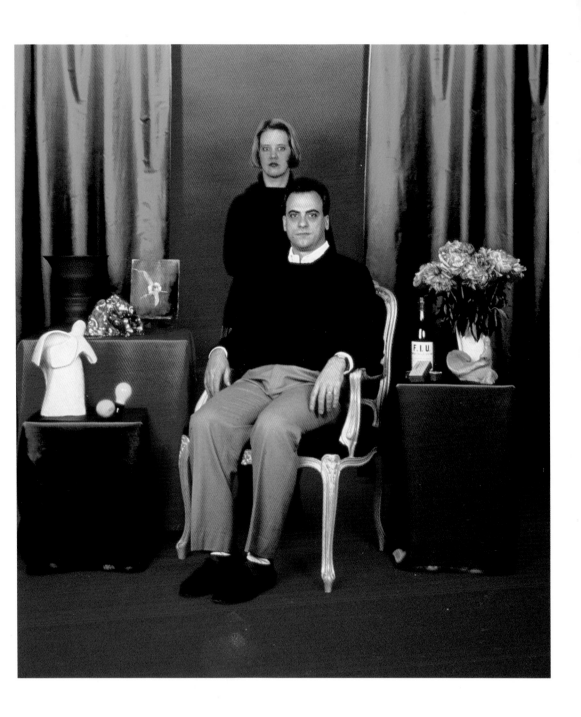

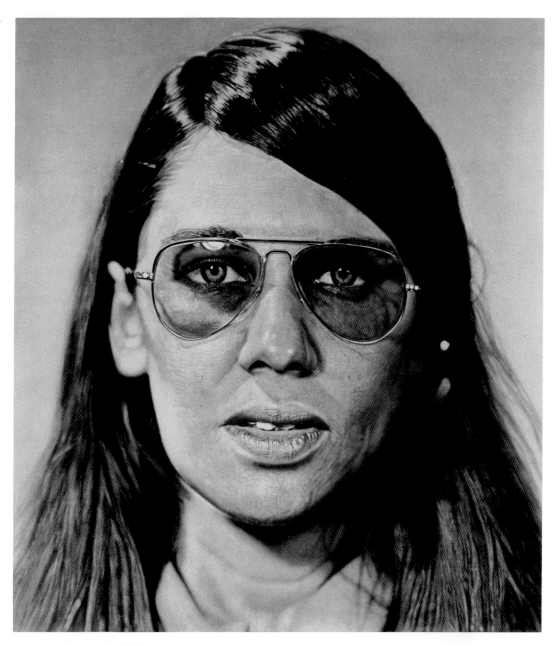

CHUCK CLOSE (American, b. 1940)
Susan. 1971
Acrylic on canvas, 8′4″ × 7′6″ (254 × 228.6 cm)
The Pace Gallery

the overlay of a grid onto a photograph, which allows him to transfer and enlarge an image onto canvas box by box. This dot-by-dot process is also akin to screen printing, the technique used to reproduce photographs in books and magazines.

Departing in various ways from traditional portraiture, the painting of *Susan* is monumental in scale only. Otherwise, it seems commonplace: the attire is casual, there is no setting to speak of, and it is black and white, all of which choices are intended ironies, pitting modernism against tradition. Susan's gaze is steady and her position fixed as if stopped in action, and therefore this portrait maintains the candidness of a snapshot or stiffness of identification photographs, unpretentious and certainly rooted in the moment instead of timeless and eternal. Compare this portrait with the self-portrait by Rembrandt on page 104, and consider how color, pose, lighting, and costume are used to encourage us to read meanings into the paintings, to define feelings and find evidence of inner conditions. Despite Close's painstaking technical effort, all of these allusive qualities are somehow missing.

This total involvement with how photographs work and the many ways in which they relate to old and new traditions of visual information is a subject of vast appeal to contemporary artists. In introducing photographic themes into painting, artists assert that, despite its conventions, painting is a mutable medium, capable of extending to a vast range of vocabularies, borrowing and imitating as well as inventing.

Georgia O'Keeffe used the camera's capacity to frame and to create flattened views in order to explore abstractions, not realism. For example, in *Lake George Barns,* she focuses on the flat surface of a series of rural outbuildings and on squares of window glass, pitched roof planes, and lines of foundations and terrain. In O'Keeffe's view, these create an asymmetrical arrangement of muted tones — even the glass reflections, the shadows, and the slight variations in hue are composed to add to the balanced precision of this work. A humanizing element is the variation allowed in sky and earth. What is emphasized is a composition in subdued tones, itself an elemental representation of pure harmonies that O'Keeffe enables us to appreciate.

Realistic painting is also mined for possibilities beyond its references to photography, one of which is its unparalleled capacity to remind us of human experience. For example, it can suggest a narrative: Edward Hopper's haunting, nostalgic *New York Movie* presents a tableau for a mundane little drama about twentieth-century living. Hopper invites us to imagine who the usherette is and what her life might be like, to consider her loneliness or boredom, even to wonder what movie seems not to be capturing her attention. The quality of color, the lighting, the architecture, the black-and-white film, the costume, even the existence of an usherette all take us to a moment, not so long ago but still far away, and engage us in a nostalgic reminiscence.

Mexican painter Frida Kahlo used the record-keeping potential in realistic imagery to tell her autobiography in painting. One of a lifelong output of self-portraits, *Self-Portrait with Cropped Hair* shows Kahlo with short hair, strong black eyebrows, baggy man's suit, and determined gaze. She appears defiant yet delicate and beautiful, a pair of scissors resting uneasily in her lap, strands of what must be her hair still within its menacing blades. The otherwise empty landscape is strewn with hair. Adding to that visual diary entry, she fills in the bleak, lifeless sky with bars of music and lines of text, the lyrics of a popular song. The text translates,

GEORGIA O'KEEFFE (American, 1887–1986)
Lake George Barns. 1926
Oil on canvas, 21⅛ × 32″ (53.3 × 81.3 cm)
Walker Art Center, Minneapolis. Gift of the T. B. Walker
 Foundation, 1954

EDWARD HOPPER (American, 1882–1967)
New York Movie. 1939
Oil on canvas, 32¼ × 40⅛″ (81.9 × 101.9 cm)
Collection, The Museum of Modern Art, New York.
 Given anonymously

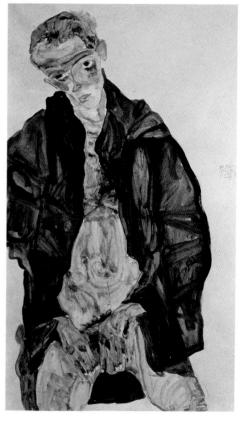

FRIDA KAHLO (Mexican, 1910–1954)
Self-Portrait with Cropped Hair. 1940
Oil on canvas, 15¾ × 11″ (40 × 27.9 cm)
Collection, The Museum of Modern Art, New York. Gift
of Edgar Kaufmann, Jr.

EGON SCHIELE (Austrian, 1890–1918)
Self-Portrait in Black Cloak, Masturbating. 1911
Gouache, watercolor, and pencil on paper, 18⅞ × 12⅝″
(47.9 × 81.3 cm)
Graphische Sammlung Albertina, Vienna

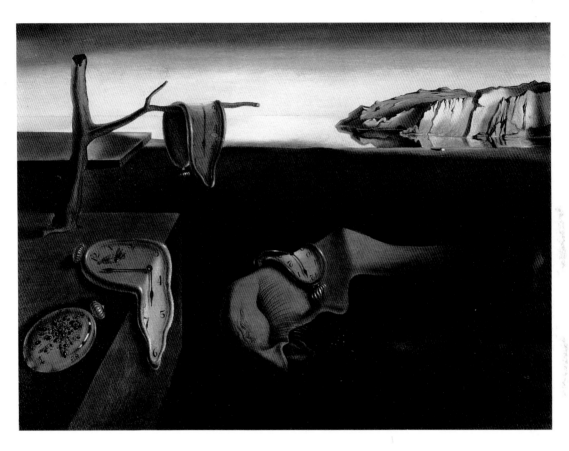

SALVADOR DALI (Spanish, 1904–1989)
The Persistence of Memory. 1931
Oil on canvas, 9½ × 13″ (24.1 × 33 cm)
Collection, The Museum of Modern Art, New York.
 Given anonymously

"Look, if I once loved you, it was just because of your hair. Now that you are bald, I don't love you anymore." If we think about the content of these lyrics and consider the apparent hair shearing recorded in the image, the artist's defiance takes on the character of a challenge. Her suit carries overtones, too, having to do with the assumption that long hair, clothes, and femininity are somehow interconnected. We start to wonder about the other character in this obviously complicated love story and who is going to win the battle of wills.

Using realistic depiction toward expressionist ends, Egon Schiele distorts his models—often himself—into positions of such discomfort that we see them as seismographs of tortured souls. Using few props, just enough clothing to dramatize an act of sexual self-involvement in which he is engaged, Schiele combines edgy, jagged lines, a twisted body, dis-figurement, and a haunted gaze to implicate us in his psychosexual obsession. The recognizable elements ground us; the subjective rendering gives us food for thought.

Painters such as Egon Schiele are drawn to what depictions of people can do to prepare us for finding qualities and capacities that usually lie beneath the surface in a manner quite similar to the way in which Irish playwright Samuel Beckett includes details that ground us in "real" absurdities, not wholly foreign to our daily existence, before he drifts into an irrational landscape.

In summary, then, recognizable images can be interpreted on several levels and can be probed for meaning beyond the obvious. Although each artist depicts distinctive figures, Hopper's lonely usherette, Kahlo's shorn rebel, and Schiele's distorted model express very different aspects of experience because of the way in which the artists use color, line, tech-nique, and setting.

Surrealist artists often use recognizable subject matter, also, but take great liberties with logic in order to transport us into dream states. In fact, Salvador Dali once said, "My paintings are handmade Technicolor photographs of my dreams." Dali's famous *Persistence of Memory,* thought provoking even in its title, establishes an eerie seashore of flat beach, still water, and sheer rock cliffs. The strong light source and deep shadows do not seem to follow any logic. Dali also inserts unlikely architectural platforms into the scene, a dead tree protruding from one. A series of melting pocket watches, completely out of scale with the landscape, weighs down the left side of the painting. One of them is infested with ants; a fly lights on another. Center stage, Dali focuses us on a disembodied, headlike piece of debris that emerges from deep shadow, a sort of horrifying ghostlike specter; some say it is a self-portrait. Thus he intertwines realistic elements, although a little askew, with impossible ones, creating a not-so-wonderful wonderland that nags at us, as some dreams do, to look for the meanings in symbols he employs.

Just as Surrealists often stage impossibilities, painter Ed Paschke transforms images (originally photographs, often of pop-culture figures), heightening their intensity with bright, bizarre color to produce effects that are at the same time eerily beautiful and disquieting. In *L'Impression* he suggests a face—buried under painstakingly applied paint—that might be recognizable except that most personality-giving characteristics have been obliterated. He presents an impression of time no less vivid than Hopper's, but instead of being specific, Paschke's time frame is an endless urban night. In this image we see a face in profile, a strangely incandescent man who seems to be peering at him-self; the mirror's return is masked and menacing.

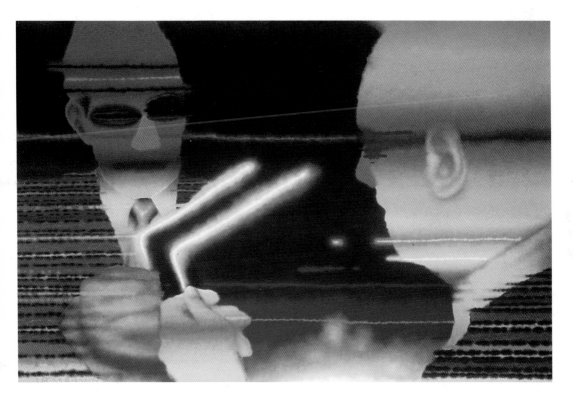

ED PASCHKE (American, b. 1939)
L'Impression. 1981
Oil on canvas, 32 × 48″ (81.3 × 122 cm)
Courtesy Phyllis Kind Gallery

JEAN ARP (French, 1886–1966)
Collage Arranged According to the Laws of Chance.
 1916–17
Torn and pasted paper, 19⅛ × 13⅝″ (48.6 × 34.6 cm)
Collection, The Museum of Modern Art, New York.
 Purchase

The flame of the match he holds resembles photography of light in motion, a burned-in kind of line, and the impression of carefully controlled burning is echoed elsewhere. The title, translated as *The Impression,* refers perhaps to the effect of personality, and it is also a play both on the mirror's reflective capacity and the Impressionist painting style, which shocked the audiences of its day, as this image may also, by concentrating on the effects of light. But instead of exploring Impressionism's sunlit surfaces, Paschke transports us to a world artificially lighted, possibly by neon—garish, ominous, potentially evil.

Both obscuring images and setting up contradictions address a desire to deal with meanings that are not fixed but that are lifelike in the sense of being complicated and open-ended. Such work gives the artist—and the viewer—latitude for discovery. Internal complications and inconsistencies can be set up by technical craft as well. For example, one can leave certain aspects of creation up to chance by letting paint drip, finding its own shape and form. As the title of Jean Arp's *Collage Arranged According to the Laws of Chance* suggests, Arp tore two colors of paper into irregular rectangles and squares. He dropped them, perhaps several times, until he observed a pattern he wished to repeat on paper. He abdicated some of his choice-making to let chance contribute to the work's ultimate effect. In so doing, he thought some natural truth might become visible, some greater order than could be imagined by conscious thought. By removing his hand to some degree, he hoped to reveal something new and fresh, as much a surprise to him as to us, the viewers.

This urge to avoid predetermined meaning as a means of self-exploration is also evident in the work of Arshile Gorky, whose biomorphic structures may remind us of landscape elements or figures, animals,

or objects, such as furniture; yet, precise identifications are difficult to pin down. While Dali created concrete but impossible configurations, Gorky's paintings seem like partially heard conversations or very vague and distant memories.

In *The Liver Is the Cock's Comb,* even the title defies easy comprehension despite the precise meaning—or meanings—of each word. The "liver" might be an internal organ or "one who lives," for example, and the differences conjure up distinct images, none of which might seem illustrated in any literal sense by the painting. The painting itself is even more enigmatic, appearing to result from spontaneous impulse more than careful consideration. Lines are very deliberately drawn, as if to outline objects, creatures, or plant life, yet nothing is actually identifiable. Both the drawn figures and some of the brightly colored areas seem detached from the background. If we concentrate on the white areas, we see further contradictions; sometimes they seem to be in the background and at other points they shift to come forward.

There almost seems to be two paintings, the first laid down as an earthy atmosphere, sketchy, somber toned, and quiet. The second floats above it, colorful, edgy, and chaotic—a galaxy of forms, some carefully delineated, some softly brushed, aimless but energetic, seeming to want to escape the painting's boundaries. While there is a distinct quality of buoyancy, there are also dark holes and murky passages, particularly at the edges. Swinging from subtleties to starkness, Gorky seems intent upon setting up oppositions, presenting forms and volumes at one moment, flatness or voids at the next. He moves us beyond specific associations to elicit vague feelings, attempting, perhaps, to fathom the nonverbal realities that the upheavals of the twentieth century have made standard operating procedure. We have only to think of the psychological impact of atomic warfare (this was painted in 1944) to begin to drift into realms best described by alternating patches of dark and light, of blood reds and shadowy browns.

The investigation of unseen worlds does not preclude the pursuit of beauty. Odilon Redon used figures, creatures, and subjects as emblems of such irrational phenomena as myths, dreams, and the spiritual world. In probing mysteries, Redon could create images of such consummate beauty that we shall always recognize and cherish them. *Vase of Flowers* presents a subject of almost universal appeal, ensuring pleasant associations. A warm gold and purple infuse the semidefined space with a sense of calm serenity, hermetic and untouchable. The flowers may remain forever fresh, but they also may transform themselves into fairies or butterflies. The natural and supernatural seem to fuse.

The use of color to create moments of beauty and repose has occurred throughout the century, and the work of artists like Henri Matisse continues to remind us of the comforting truth that, despite our hustle and even our capacity for cruelty, we have the potential to make and enjoy passages of lyricism.

Creating paintings of beauty and harmony was important to Matisse, whose influence was certainly a factor in much art of the century. Throughout much of the artist's career, decorative patterns of the sort familiar to us in various forms of Oriental carpets dominated the backgrounds of his paintings. Late in his life, when he could no longer stand and paint, his irrepressible urge to make art led him to cut shapes out of large sheets of painted paper, which he then arranged in appealing patterns. One such work is called *The Swimming Pool,* a mural created to cover his dining-room walls. The shapes range from abstract to recognizable, but all share a

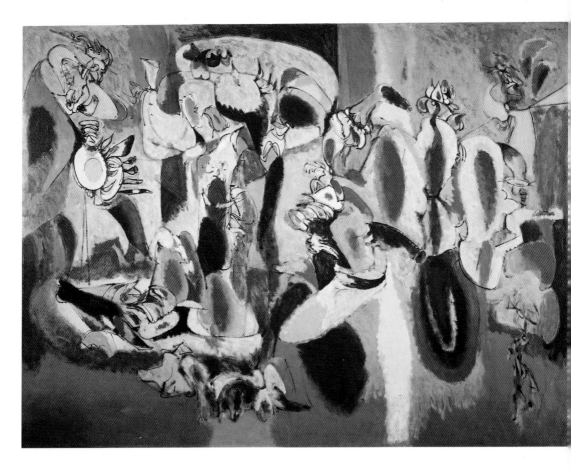

ARSHILE GORKY (American, b. Armenia, 1904–1948)
The Liver Is the Cock's Comb. 1944
Oil on canvas, 72 × 98″ (182.9 × 248.9 cm)
Albright-Knox Art Gallery, Buffalo, New York. Gift of
 Seymour H. Knox, 1956

ODILON REDON (French, 1840–1916)
Vase of Flowers. 1914
Pastel on paper, 28¾ × 21⅛″ (73 × 53.7 cm)
Collection, The Museum of Modern Art, New York. Gift
 of William S. Paley

sensuousness that seems to embody the rolling motion of water, the splash of pool play, or the forms of swimmers diving and cavorting. The rich mustard background seems to signal a warm, sun-drenched day, and the white stripe, perhaps the pool itself, creates a stable reference for all the other activity. The brilliant blue could symbolize both sky and water but is in itself inviting and enveloping. This frolicsome, sensory diversion is distanced from the angst-filled exploration of other artists yet still descriptive of experience.

Covering large expanses of canvas with strong colors, Helen Frankenthaler arrests us not with the authority of power but with the invincibility of beauty. It is a different kind of beauty from Claude Monet's Impressionist scenes or Redon's flowers, in part because it cuts itself entirely free from objects that are attractive in themselves. Beauty in Frankenthaler's art emerges from the attractive-

ness of her color choices, their subtle variations, and the way they relate in broad, elegant fields. She achieves curious balances that are intuitive, not geometric. For example, a large mauve block seems to be drifting into *Mauve District* from the upper right, but powerful white seems to offer a home in which it can comfortably rest. A strong foundation of green and gold frames the mauve monolith. In the same way that we watch patterns in water or surface changes on a velvet dress, our eyes roam the slightly mottled surface of the canvas for varying intensities of color.

Frankenthaler makes a point of exploring the use of canvas that has not been "primed" or sealed to harden the cloth, the latter having the effect of keeping the paint on the surface. Instead, she paints on porous, unprimed canvas, with the result that the paint bleeds into and stains the fabric. This technique creates an effect fascinating to many

HENRI MATISSE (French, 1869–1964)
The Swimming Pool. 1952
Gouache on cut and pasted paper on burlap. Nine-
 panel mural in two parts: 7'6⅝″ × 27'9½″
 (230.1 × 847.8 cm); 7'6⅝″ × 26'1½″
 (230.1 × 796.1 cm)
Collection, The Museum of Modern Art, New York. Mrs.
 Bernard F. Gimbel Fund

artists because of the way it epitomizes the reality of paintings as flat surfaces—not windows of illusion but grounds (canvas) integrally connected to medium (painting). It also exemplifies the excitement with which many modern artists have approached material and techniques as themselves inspirations for artistic innovation.

In contrast to Frankenthaler, Barnett Newman's interest in color seems at first to focus on its formal properties. By some system that appears to be both calculated and intuitive, Newman determines the outer dimensions of his canvas as well as the divisions within, which are created by narrow stripes of color. The central square is a rational decision, probably related to the notion of the square as a symbol of human reason. The stripes (he called them "zips") separate large blocks of color, painted so meticulously that you see no traces of brushwork, no variations in tone, no surface textures to distract

you. Newman thus creates volumes of color so intense that they seem to create auras about them that extend well beyond the canvas.

The huge expanse of red in *Vir Heroicus Sublimis* is broken by the "zips," which vary in width and hue and which supply a source of visual play. Staring at the joins between individual colors, we can see how the juxtaposed colors interact, seeming to vibrate. The optical effects can be appreciated further by staring at a fixed point in the image for a short period, then closing your eyes to wait for an afterimage to appear. Observe what colors you see and what reads most strongly. These powerful visual effects are part of what Newman counts on happening, whether consciously or subliminally. When you think about the title, *Vir Heroicus Sublimis* (Man Heroic and Sublime), you begin to understand why: Newman uses color and composition with the passion of Mondrian, creating

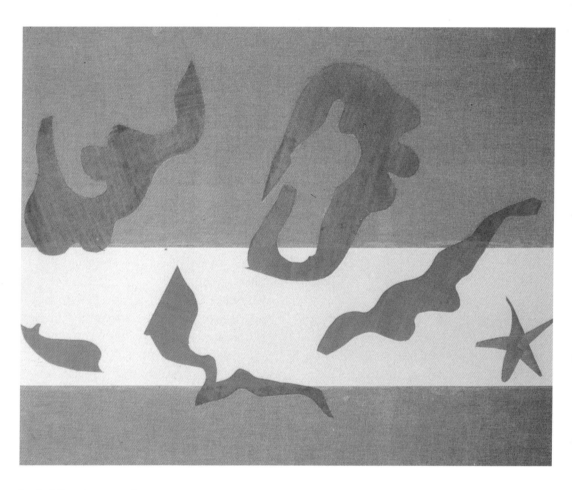

Detail of *The Swimming Pool*

HELEN FRANKENTHALER (American, b. 1928)
Mauve District. 1966
Synthetic polymer paint on unprimed canvas,
 8'7" × 7'11" (261.5 × 241.2 cm)
Collection, The Museum of Modern Art, New York. Mrs.
 Donald B. Straus Fund

BARNETT NEWMAN (American, 1905–1970)
Vir Heroicus Sublimis. 1950–51
Oil on canvas, 7'11⅜" × 17'9¼" (242.2 × 513.6 cm)
Collection, The Museum of Modern Art, New York. Gift
 of Mr. and Mrs. Ben Heller

with seeming simplicity images intended to evoke a spiritual essence. Just as the designers of Gothic cathedrals found a proper spiritual expression through verticality and light, Newman spent much of his life developing expressive means that could serve as metaphors for truths about the human condition.

Shifting attention to a different sort of motivation, we again look at today's milieu, in which artists face an unprecedented amount of information about the past, just as we all do. One response to this is to borrow ideas, images, styles, materials, and subjects that first appeared elsewhere and often for distinctly different purposes. For example, when Pablo Picasso first encountered tribal art, he was consumed with wonder and awe, and he began to include its forms in his painting, without concern for its original intent (see p. 23). While citing a source (quoting or paraphrasing) is a literary convention, often involving footnotes to credit the original context, visual artists usually feel no such compunction. Nonetheless, they enthusiastically embrace certain aspects of past art, almost as much as they reject others.

Artistic appropriation—the subsuming of vocabulary created for one purpose and putting it to another—often happens with intentional irony and sometimes humor. A hallmark of Roy Lichtenstein's brand of Pop Art is his appropriation of comic-style drawing and cheap, dot-screen printing techniques (the kind you see in comic books) for his paintings. But he also casts about in art history to find subjects and styles to mimic in his popular vernacular.

His giant murals of the 1980s cram an enormously eclectic array of images into collage-like summations of virtually all visual systems of the twentieth century. For example, in *Mural with Blue Brushstroke,* commissioned for New York's Equitable Building, Lichtenstein's central image is a blue cascade that could be simply an abstract gesture amid recognizable imagery. It could also be a stylized, exaggerated brushstroke of the sort one might see in Franz Kline, except it is an unlikely baby blue. It might be a waterfall taken out of its landscape to symbolize nature surrounded by culture, not yet overcome but still having to fight for its own. Let your eye roam from subject to subject in this painting. Try to recall where you might have seen elements in it before. This is likely to be the pleasure that is in it for Lichtenstein, who is an astute but lighthearted chronicler of our visual times.

Izhar Patkin appropriates in less gentle ways, imitating and outrageously adapting styles and subjects of earlier eras, mixing them shamelessly with pop-culture references. In *Palagonia* his diverse sources include seventeenth-century Italian artist Gianlorenzo Bernini's *The Ecstasy of St. Theresa* and the Baroque grotesques of the Villa Palagonia in Sicily, which he intermixes with sentimental greeting-card images. Using this vocabulary, Patkin creates sculpture out of paraffin caked over a rigid armature. He takes a look at the fine line between spiritual ecstasy, penitential self-flagellation, and erotic passion. He does so in order to understand more about human nature; at the same time, he pokes fun at those who theoretically sublimate their physical being in order to purify the spirit while nonetheless exhibiting behavior that looks dangerously passionate. The use of paraffin seems to underscore the issue of heat, whether it is a candle melting or burning at both ends. Through the use of gold and other decorative devices, he cites both religious art traditions and material hedonism, which again look very much alike at times. He

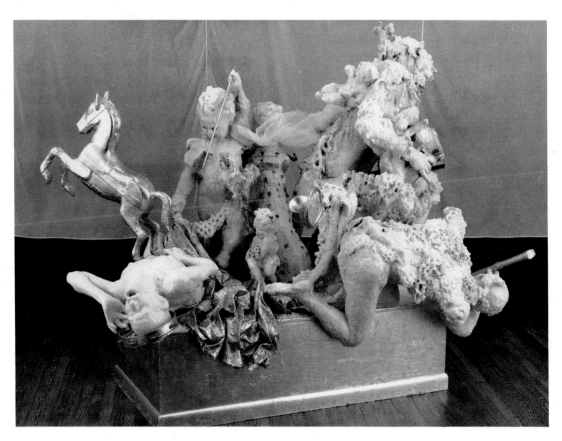

indulges in excess and exaggerations for humorous and ironic reasons, but not without the sympathy that comes hand in glove with teasing.

The tendency toward irreverence, toward arguments between the tasteful and the tasteless, is itself often taken to the point of completely rejecting what is considered proper or appropriate. From Meret Oppenheim's *Object* (popularly called the "fur-lined teacup") to Andy Warhol's infamous soup cans, there is a great deal of art that is iconoclastic, delighting in undermining those who insist on a place of privilege and preciousness for art. These artists assert that creativity is not being able to make something wonderful; instead, it is finding wonder in what one discovers in the world. As suggested before, some-

IZHAR PATKIN (Israeli, b. 1955)
Palagonia. 1990
Wax, pigment, metal leaf, and fabric over plaster,
 72 × 96 × 72″ (183 × 244 × 183 cm)
Courtesy of Holly Solomon Gallery, New York

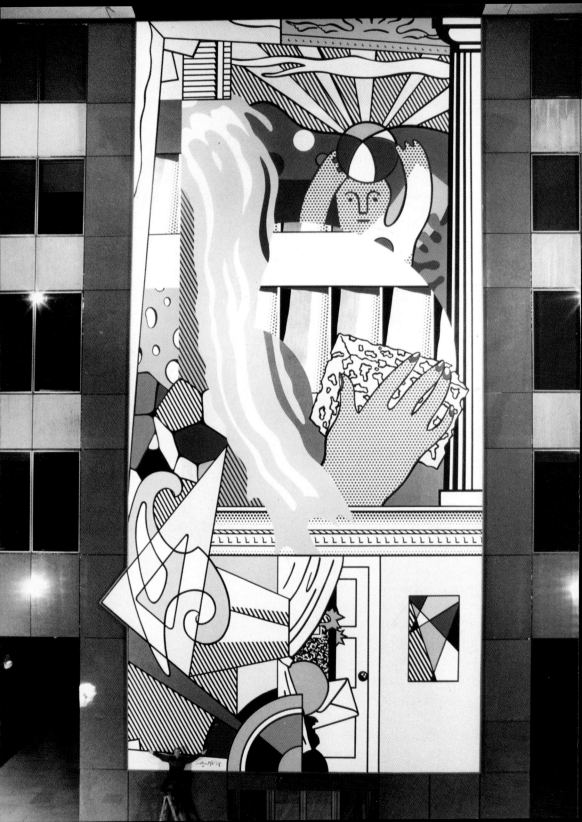

MERET OPPENHEIM (Swiss, b. Germany, 1913–1985)
Object (Le Déjeuner en fourrure). 1936
Fur-covered cup, saucer, and spoon; cup 4⅜″ (10.9 cm) diameter; saucer, 9⅜″ (23.7 cm) diameter; spoon 8″ (20.2 cm) long; overall 2⅞″ (7.3 cm) high
Collection, The Museum of Modern Art, New York. Purchase

ANDY WARHOL (American, 1928–1987)
Big Campbell's Soup Can, 19¢. 1962
Synthetic polymer silkscreened on canvas, 72 × 54½″ (182.9 × 138.4 cm)
Courtesy of the Menil Museum, Houston, Texas

ROY LICHTENSTEIN (American, b. 1923)
Mural with Blue Brushstroke. 1986
Acrylic on canvas, 68′ (20.4 m) high
Commissioned by The Equitable

times this is taken to the extreme of being excited by ideas themselves without visual representation. In much of this transgressive work, the artist's act is itself unpretentious, simple, even mechanical; the machinations of the artist's mind are not.

Oppenheim's *Object* is an intentional absurdity. It is fun to look at, even funny, but virtually all applications of an artistic analysis arrive at dead ends. An undistinguished, mass-produced, functional object is rendered useless by the application of a tired fur lining. A fur-covered spoon accompanies the set as if to emphasize its subverted conventionality. It is small and uncommanding. Nevertheless, it raises every possible question about what is art and what is art's purpose in our lives. As soon as Oppenheim asserted her right to put this on display and as soon as other artists accepted such "anti-art," we were asked to think about creativity as a mental activity: Is what the artist actually makes more or less important than the thinking that precedes it? Tradition argues "more"—the object is itself imbued with sometimes extraordinary value and authority. But some modern artists argue "less," and when this happens the creative response (the viewers' domain) becomes not only perceptual and visceral but also conceptual.

Andy Warhol operated within this framework, giving more emphasis to ideas than precious artifacts. He interpreted the role of art and the artist as integral parts of everyday experience. His subject matter always came from popular culture: stores, magazines, newspapers, film, television. His techniques also were commercial, particularly his dependence on cheap, available photography and silkscreen printing. He repeated images in the way that news sources use pictures again and again. He focused on fame and celebrity, even creating starring roles for soup cans and Brillo boxes, the kinds of products that took the ease-seeking American householder by storm after World War II, an era of unprecedented consumerism marked by previously unfathomed creativity in package design and advertising.

Warhol positioned himself as an observer of pop phenomena and made art about what he saw, none of it precious in the way of Rembrandt, not carefully crafted or based on immense skill, not psychologically penetrating or emotionally revealing. Instead, Warhol's art probed contemporary culture, how we live, what we value. Is an array of soup cans today's version of a still life? Are tabloid photographs of Elvis or Marilyn today's *Mona Lisa*?

Warhol was not passing judgment; he simply examined the effects of modern technology and communication systems on the creation of myths, beliefs, and customs. He was plainly knocked out by the fact that on table after table throughout America, literally millions of look-alike soup cans were being opened for lunch. He was stunned by the fact that magazines had millions of readers who saw the identical pictures and read the same texts week after week; that many television programs drew millions more worldwide to view identical images and information, all of it possibly fiction as much as fact. Because of his subject matter and style, Warhol's work can be reproduced easily, which helped make him famous and appreciated by a wide audience. It also encouraged versatility, giving him impetus to go beyond traditional art mediums to experiment in books, films, and magazine publishing, on all of which he left an indelible mark.

The world of product design and promotion has influenced many other artists, such as Hans Haacke, whose art takes a visual form based on advertising, which he examines to find various possible levels of meaning. He studies the behavior of corporations,

HANS HAACKE (German, b. 1936)
The Right Life. 1979
Color photograph on three-color silkscreen print in
 brass frame under glass, 50¼ × 40¼"
 (127.6 × 102 cm)
First exhibited in one-person exhibition at the John
 Weber Gallery, New York
Courtesy of John Weber Gallery

looking for discrepancies between the image put forth by a company through its ads and its practices as an employer, a contributor to the environment, and as an actor within a broad social context. The result is work that adopts the innocuous look of a hair-product-campaign ad, but which Haacke subverts to expose the way in which women who work for a particular company are treated—and by extension the implications for all women who are theoretically represented by the ad. Haacke juxtaposes the real and the ideal—or at least the idealized— and in so doing he updates a traditional subject of art.

The interplay between "high art" and "pop culture" is sufficiently powerful that artists who choose to appropriate the techniques and mediums that talk to millions can create images that become "household words." A case in point is Robert Indiana's *LOVE.* Few people in America are unfamiliar with this image, and when first introduced in 1966, it was probably seen around the world. In making it, Indiana reveals his awareness of a culture of signs, insignia, and trademarks. He appropriates the tools of graphic designers, whose task it is to encapsulate corporate identities in letters and patterns that emblazon America. Indiana knew well the potential impact of a familiar poster typeface combined with intense contrasting colors, one red hot, the others cool yet powerful. He understood the stability of the square and of a strict grid and how to enliven this structure by the tilt of one letter and by the interaction of color. He knew the implications of the loaded word *love*—its particular meaning for the 1960s, its sentimental side, and its profound importance; he knew its capacity to affect. He thus created a masterful emblem of a period that is also a summary statement of just how coherent and powerful contemporary graphics can be. Moreover, it

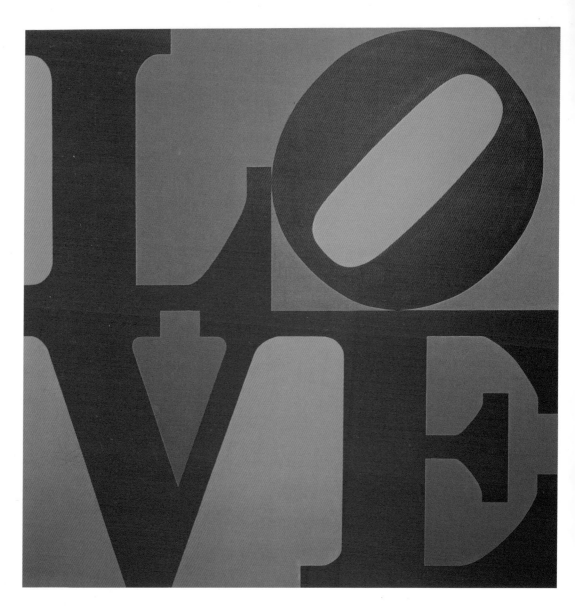

ROBERT INDIANA (American, b. 1928)
LOVE. 1966
Acrylic on canvas, 71⅞ × 71⅞″ (182.6 × 182.6 cm)
Indianapolis Museum of Art. Purchased from James E.
 Roberts Fund

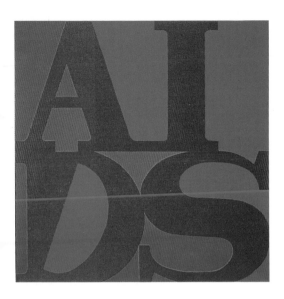

GENERAL IDEA (A. A. Bronson, Felix Partz, Jorge Zontal,
 Canadians)
AIDS (Cadmium Red Light). 1987
Acrylic on canvas, 30 × 30″ (76.2 × 76.2 cm)
Courtesy of Koury Wingate Gallery

is a reminder that mass media have the capacity to
manipulate and trivialize.

Love is a traditional subject of art, usually
depicted through images. Ironically, it is rendered
obvious and concrete by Indiana through the
abstract medium of letters. This *LOVE* therefore
began as a reference to traditions in art, and also as
a fine-art object in itself, but quickly became part of
popular vernacular. It has been used in hundreds of
contexts and manners, with and without the artist's
permission. It has seeped into the culture the way
that "I ♡ NY" or Vincent van Gogh's *The Starry
Night* has — and has been transformed along the
way. It is this particular process that intrigues a trio
of Canadian-born artists who call their collaboration
General Idea. They address both the effectiveness
of images at communicating as well as their con-
sequent politics — the way images operate to inform
and shape opinion.

Aware that Indiana's *LOVE* is probably recognized
without any longer being seen (in the way that we
might mentally process a stop sign), General Idea
appropriated *LOVE,* replacing the letters with *AIDS.*
Suddenly this icon is recycled: Love becomes AIDS.
Regardless of Indiana's intentions, General Idea used
the design in order to attract attention to a major
health crisis. Did they intend to make us equate the
two? Afraid as many of us are of disease and dying,
especially of infections that seem to affect segments
of the public some find morally reprehensible,
specifically when controversial life-styles seem
to be an issue in contracting the disease, is the
appropriation of *LOVE* a subversive act on the part of
General Idea? If the emblem *LOVE* encapsulated the
1960s, is *AIDS* equally emblematic of our troubled
moment with regard, not just to AIDS, but also to
environmental issues, peace, and the battles over
freedom of choice? Is General Idea saying that love

is required to understand and perhaps to stop this infectious disease?

Because Indiana's *LOVE* seemed spontaneously to capture the imagination of America, General Idea has consciously sought exposure for *AIDS* in outdoor displays, billboards, and posters, taking the image to the streets. They recognized that when fine art becomes a part of popular culture, it can become part of the politics of change.

But the impact of pop culture is not an attraction for all artists. It has also produced a reaction among some who fight notions of marketing and communication, who redouble their efforts to be unique and irreproducible and to make work that must be experienced firsthand to mean much. Some artists have pulled out of the market arena altogether, making, for example, enormous, often hard-to-see, impermanent sculpture out of the land itself — earthworks, they are called — that explore the relationship between human-made expression and nature. Others make temporary sculptures, often very large and designed to be installed in particular sites — site-specific installations — which tend to heighten our awareness of either a space or of a manipulation of space, fighting the tendency for us to overlook the commonplace. Others, whose interests are more theoretical and whose roots are in geometric abstraction, focus ever more narrowly on scale, shapes, and materials, making art termed "minimalist." Somewhat like meditations or other attempts to simplify and eliminate, Minimalist art seeks a purity of expression that transcends daily reality.

The motivations of artists laid out in this chapter mostly address the question, Why do artists do what they do? The points made give rationales, not justifications, simply to help us get beyond an impulse to overlook something that seems foreign and perhaps even hostile. Therefore, instead of dismissing a large white canvas bearing no discernible mark, for example, we might acknowledge that the artist may be concerned with the flatness of canvas, with quiet, reflection, and compositional simplicity, which builds on and is even more refined than the work of Mondrian.

These motivational forces — like much else in this book — are presented as starting points so that, instead of being put off by unfamiliar, unwelcoming material, we have a key with which to open the door to understanding — an understanding that assumes active inquisitiveness on the part of the viewer, who actually completes the work by thoughtful probing of its array of meanings.

ROBERT SMITHSON (American, 1938–1973)
Spiral Jetty, Great Salt Lake, Utah. 1970
Mud, salt crystals, rocks, water, algae, 1,500′ (450 m)
 long × 15′ (457 cm) wide
Courtesy of John Weber Gallery, New York

Partly due to a desire to connect with nature, partly because of the delightful temptation to work on an enormous scale, and partly to avoid a troubling interrelationship between the making of discrete art objects and certain consumerist tendencies that they abhorred, artists in the 1960s and 1970s like Robert Smithson took to making huge earthworks, that no one could buy and few could actually see, except in drastically reduced reproduction, such as photographs. *Spiral Jetty* is both natural and an imposition onto the landscape, one that will eventually erode completely, emphasizing the mutability of all things, a notion that nature seems to accept more easily than humankind.

CHRISTO (American, b. Bulgaria, 1935)
Surrounded Islands, Biscayne Bay, Greater Miami,
 Florida. 1980–83
Pink woven polypropylene fabric, 6.5 million sq. ft.
 (1.9 million sq m)
Copyright Christo, 1983

In short-lived projects like *Surrounded Islands* —
where islands in Miami's Biscayne Bay were given hot-
pink lily pads for several days — Christo has helped
define "public art" as a process involving thousands of
people — from engineers and marine biologists to city
council members and art dealers to members of the
press and day laborers. This process engages the
attention of an unprecedentedly wide audience, who
argue the merits of his proposals as well as work with
him to see it accomplished. His aesthetics invariably
increase consciousness of natural and manufactured
phenomena, each enhanced when they exist in
harmony.

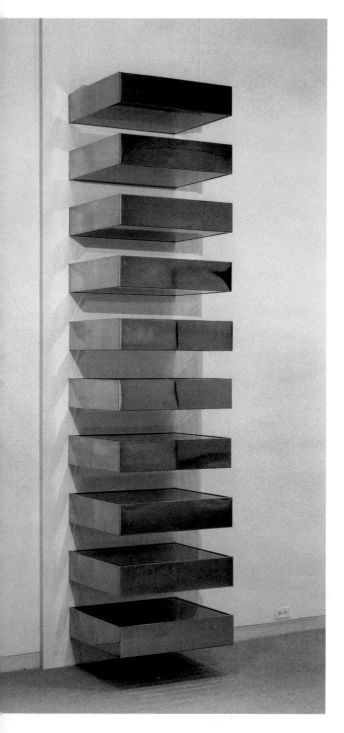

DONALD JUDD (American, b. 1928)
Untitled. 1969
Brass and colored Plexiglas on steel brackets; ten
 pieces, each $6\frac{1}{8} \times 24 \times 27''$ ($15.5 \times 60.8 \times 68.6$
 cm), with $6''$ (15.2 cm) in between
Hirshhorn Museum and Sculpture Garden.
 Smithsonian Institution. Gift of Joseph H.
 Hirshhorn, 1972

In this sculpture, Donald Judd has taken a precisely
designed and fabricated form—a wall-mounted box
whose outer surface is polished metal and whose upper
and lower faces are reflective—and created a vertical
stack of them, precisely hanging them to observe
absolutely straight lines and identical spacing. Very
formal and with little to distract us from its materials
and shapes, such sculpture tends to make us aware of
space. Reflections and shadows inform us just as much
as the forms do, and the challenge of looking at
them—which is not so different from that presented
by Ansel Adams or Christo—is to become more
sensitive to considerations of detail and light, for
example, that we might normally overlook.

ROBERT RYMAN (American, b. 1930)
Installation View. Dia Art Foundation, 1989
Left to right: *Cast* (1988); *Archive* (1980); Untitled
 (1965); *Alternate* (1988)
Courtesy of Dia Art Foundation

An even more severe Minimalist than Donald Judd, Robert Ryman has been making white paintings for many years, altering them subtly by using different paints on different surfaces; varying sizes of brushes and relative prominence of the brushstrokes; and examining different systems for mounting works on the wall, different lighting sources, scales, and ratios of height to width, and so forth. By concentrating on a very narrowly defined problem, Ryman can dramatize the fact that all vision is the perception of reflected light and can create for us islands of pure simplicity in a chaotic world, which demand of us a close look instead of a scan.

DEALING WITH IDEAS

In various parts of this book we have dealt with the centrality of ideas in modern art, and the importance of this fact makes it necessary to examine the conceptual aspects of art more deeply.

The current emphasis on ideas does not mean that art before this century was mindless. For example, whether localized, as in tribal cultures, or widespread, as in Christianity, religions throughout time have produced great art, perhaps the greatest we know, in order to convey specific information, emotional charge, and spiritual uplift. Other types of work document people's life-styles, architecture, or landscape—and more subtle messages, such as attitudes, status, and taste—and can therefore serve as primary historical sources. Rembrandt, for example, engages the eye with an enthralling technique; he also penetrates the conscious and unconscious mental states of his sitters, and he did so long before we had psychology to describe the meanings of such states.

All art embodies certain ideas about the culture that produces it. Even forms of art that seem comfortably familiar stylistically may contain subjects that are distant. Few of us remember, for example, exactly who Titus or Andromache were, what King Tut's afterlife meant to the ancient Egyptians, or how to tell Saint Barbara from Saint Inez. Even some easily identifiable work seems formidable, and there are people, in fact, who want background to help in understanding Rembrandt's somber coloration, his skillful rendering of detail, and his purposeful use of light and shadow to elucidate the psychology of his subjects.

Without background information we have an incomplete grasp of the material we see. This situation is particularly acute with regard to such culturally distant material as tribal art: we benefit

JOEL MEYEROWITZ (American, b. 1938)
Porch, Provincetown. 1977
Color photograph, 10 × 8″ (25.4 × 20 cm)
Courtesy of the artist

The desire for beauty and the need to see it in subjects that portray a harmonious balance between humans and nature are satisfied by artists such as Joel Meyerowitz in his haunting photographic compositions of light, time, and place. Where one once might have turned to painting for such inspiration, it is now more likely that the versatile, portable camera will be its source—and equally predictable that painting will be put to other tasks.

immeasurably from knowing its original context—the motives of its makers, its meanings, and how it was used. The ideas that inform the making of art are critical to grasping its full range of meanings, so it is useful to consult information sources if we seek to appreciate it fully. What is amazing, actually, is how much art reads even without this knowledge.

For modern art, understanding the culture that produced it is second nature. We know a great deal about "our times," even if we forget to associate what we know with the art we encounter. What confuses us today are the means by which ideas are conveyed. Relatively speaking, Leonardo da Vinci and Michelangelo gave us a lot to go on: recognizable subjects, reasonably clear emotional states, virtuoso technique, and often familiar, or at least discernible, narrative elements. They used the language of art—color, line, composition—as well as conventional materials in reasonably predictable albeit uniquely wonderful ways. Therefore, even if we end up wanting to know more about the mysterious *Mona Lisa,* she still captivates us. Even if we are full of questions about how he did it, how long it took, and who is doing what to whom, we are instinctively awed by Michelangelo's Sistine Ceiling. Such engagement is not always so easy today, in part because today's art often gives us less to go on.

The process of ferreting out modern art's elusive meanings requires seeing it in terms of other visual communication systems that were not available in earlier centuries. For example, if we want purely retinal pleasure today, we can find it in magazines, films, and even television, which are full of lush photography and brilliant graphics. Advertising goes for quick readability; shopping environments are wildly visual. Some of us find beauty, or at least visual excitement, in the fabric of cities, where material, scale, color, and activity combine with light

REMBRANDT (Harmenszoon van Rijn, Dutch, 1606–1669)
Self-Portrait. c. 1667
Oil on canvas, 33⅞ × 27¾″ (86 × 70.5 cm)
Collection, The National Gallery, London

Rembrandt left the world a thorough "autobiography," at least in terms of his physical appearance, which he rendered as a key to his emotions, perhaps to his soul. He did this primarily through the way he painted such features as his eyes and the set of his mouth, and of course through careful use of light and shadow to establish moods and to allow for nuance and mystery.

Couple: WE'D SAY... AT LEAST 6 HOURS A DAY.

Cowboy: I'M ASHAMED— ONLY 3-4 HOURS A DAY.

Family: WE LOVE IT— 10 HOURS A DAY.

Grandma: IT MAKES ME HAPPY—9 BEAUTIFUL HOURS A DAY!

Announcer: THE AVERAGE AMERICAN HOUSEHOLD WATCHES T.V. 7 HOURS,

10 MINUTES A DAY. ARE YOU WATCHING AS MUCH AS YOU SHOULD?

ERIKA ROTHENBERG (American, b. 1950)
7 Hours, 10 Minutes a Day. 1988
Acrylic on canvas, 50 × 66″ (127 × 167.6 cm)
Courtesy of PPOW Gallery

Most first-generation Pop artists refrained from adding subjective commentary to the images and techniques they incorporated. Recent artists such as Erika Rothenberg, who inherited this "no comment" attitude, not only find useful styles and techniques in popular culture but also comment on that culture in their work. Playful and amusing, this unlikely television commercial is designed to address a social issue as well as critique the methods of the medium.

and weather to produce a rich expression of civilization. Fashion is also readily available, allowing us to see amazing colors, fabrics, and styles in range and quantity never possible before now.

Our education comes by way of formal schooling and informal learning resources, not the least of which are the media, which give us quick hits of news, humor, drama, pathos, excitement, challenge, prowess, and enticement in measures and doses never dreamed of by our ancestors. Print and electronic media, including computers, are far more efficient teachers than frescoes. They are also more versatile and more faithful recorders of events. Therefore, an artist who chooses to be didactic, entertaining, outrageous, or otherwise to compete with powerful, omnipresent media is engaging a formidable opponent indeed. There can be little question that the ways and means of media, as well as the information they supply, conspire to influence both the look and the content of art.

We shall now look at a number of works by artists who employ different and complex visual strategies. We shall try to determine how they are influenced by issues and phenomena of the contemporary world. The first work is one of the most famous icons of art in the twentieth century, Pablo Picasso's *Guernica*. This mural-size painting focuses on the destruction of the northern Spanish village Guernica, a stronghold of Basque resistance to General Francisco Franco, the ultimate victor in the Spanish Civil War. Although rarely public in his politics, Picasso was decidedly anti-Franco. The battle at Guernica was seen as a particularly egregious massacre of innocents and it received widespread attention at the time. Picasso was so outraged that he produced this painting as a statement of his intense feelings.

Of particular note in this discussion is the fact

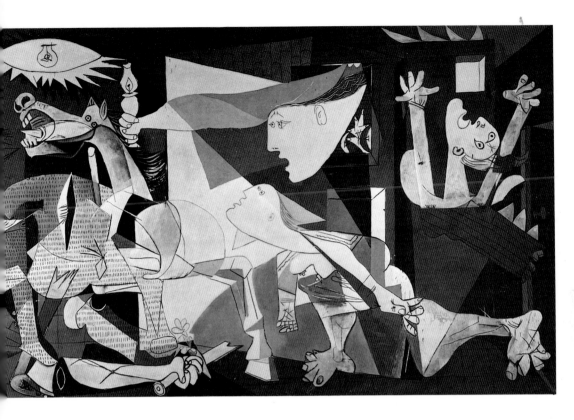

PABLO PICASSO (French, b. Spain, 1881–1973)
Guernica. 1937
Oil on canvas, 11′5½″ × 25′5¾″ (349 × 767.8 cm)
The Prado, Madrid

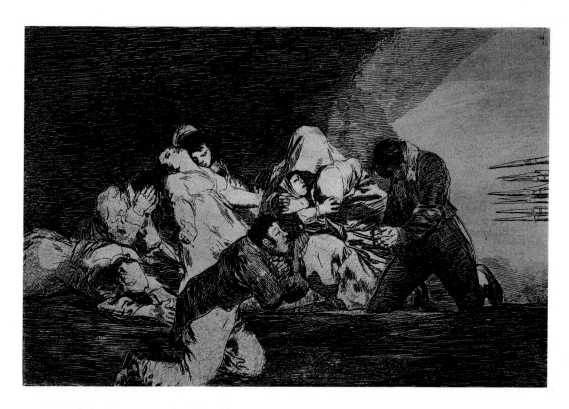

FRANCISCO JOSÉ DE GOYA Y LUCIENTES (Spanish, 1746–
 1828)
Plate 26 from *Los Desastres de la Guerra*. 1863
 edition (in *Real Academia de San Fernando*)
Etching and aquatint, 10 × 13⅔″ (25 × 34 cm)
Courtesy of the Hispanic Society of America

Goya's hard eye on the casualties of war dispel
altogether any sense of glory and victory in war.
Instead, the meanness of all aspects of war is stressed,
and his very influential images seem to penetrate the
soul of those who see them. In so doing, they not only
reflect on reality but also may produce a change in
consciousness, leading one to conclude that fighting
may be an insupportably barbaric way of resolving
disputes.

STUDIO OF MATHEW B. BRADY (American, 1823–1896)
Dead Soldier, Civil War. c.1863
Gelatin-silver print, 17 × 15⅝″ (43.2 × 39.5 cm)
Collection, The Museum of Modern Art, New York.
 Acquired through the courtesy of an anonymous
 donor

Although it is unlikely that Picasso ever saw this image of a fallen soldier in a war fought earlier and far away, photographs like this began to appear in Europe after the mid-nineteenth century, contributing to the deglamorization of military struggle. Here, the dead man's upturned face is a reality; a similar image becomes a metaphor for all wide-eyed victims.

that news media were available to broadcast the event; the conflict was recorded and relayed to people by way of photographs and film newsreels. War coverage depicting destruction was not new; in fact, the Spanish artist Francisco Goya may have started the effort to deromanticize war in his famous series of prints, *Los Desastres de la Guerra (Disasters of War),* in which he depicts starkly horrifying images of unheroic acts and dismal consequences. These subjects were also a discernible theme in U.S. Civil War photography by artists such as Mathew Brady and Timothy O'Sullivan and newspaper drawings by Winslow Homer. By 1937 it might have been imprinted in Picasso's mind that black-and-white images can best express war's truth—unglamorous, stark, and brutal—and he chose this somber palette to record his response to the disaster and suffering at Guernica.

This limited color range was also an element in Cubism, a style of art invented by Picasso and Georges Braque before World War I. Other Cubist affinities with *Guernica* include flattened forms and spaces, fragmented and rearranged objects and figures, and simplified and distorted features. Picasso seized upon these elements for *Guernica,* despite the fact that in other work done roughly simultaneously he used both brighter colors and various devices to create illusions of depth and roundness. Given a full range of possibilities, if only for dramatic purposes, other artists might have chosen more lurid color and detail, the latter by and large missing from Picasso's simplified, fragmentary heap of people, animals, and debris.

As one can see, Picasso created a tableau within what seems to be an interior space. A bare light bulb provides a cold, lifeless light, and we are presented with cramped, closed-in horror, a disaster that happened at home, not on an impersonal battlefield.

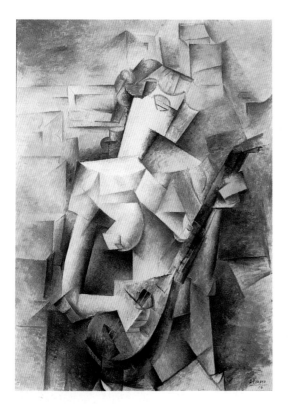

PABLO PICASSO (French, b. Spain, 1881–1973)
Girl with a Mandolin (Fanny Tellier). 1910
Oil on canvas, 39½ × 29" (100.3 × 73.6 cm)
Collection, The Museum of Modern Art, New York.
 Nelson A. Rockefeller Bequest

Serene and certainly apolitical, Pablo Picasso's relatively simple image of a female nude with a mandolin contains some of the hallmarks of Cubism. The figure and the space are barely differentiated. Suggestions of three-dimensional body parts compete with others that seem flat. The number of colors is distinctly limited. Most shapes are displaced, disjointed, and geometricized, all of which add up to a way of seeing that, despite its angularity—which is softened by grays and tans and by soft light—seems gently playful in contrast to *Guernica*.

Unlike earlier war paintings, with vanquishers triumphing over fallen enemies, in *Guernica* there are no heroes and no one gets out unscathed; this is a distinctly twentieth-century attitude toward war. Perhaps prescient, Picasso may have anticipated the even greater devastation possible from nuclear warfare, which has long-term and further reaching effects than did the conventional forces used at Guernica.

Despite many details that initially catch our eye—the contorted horse and the bull, the screaming heads, the empty-eyed, uncomprehending onlookers who stagger in from the night or swoop in from above—our eyes tend to dart around this picture, seeing ever more poignant signs of destruction, again Picasso's way of making us feel not only the personal implications of such events but also the horrifying equality of it all. We are reminded less of Homer's *Iliad* than of Euripides' *The Trojan Women* by the painting's focus on the losses of war, not the victories; on the innocent victims, not the warriors who are sustained by some idea of right, glory, or inevitability.

The ideas that inform as well as the message conveyed by *Guernica* are accessible to our eyes and minds. Of course, it helps to recall the Spanish Civil War and to know that Picasso was born a Spaniard, despite nearly a lifetime spent in France. It is pertinent also to know the characteristics of Cubism. But the point is that *Guernica* reads without such background if we look patiently and compare what we see to visual memories, of which we have plenty. Compare, for example, the difference between *Guernica* and a documentary photograph or the latest war film you may have seen. It is different, isn't it? And in this difference we have the context for seeing specifically what Picasso has accomplished in *Guernica*.

Detail of *Guernica*

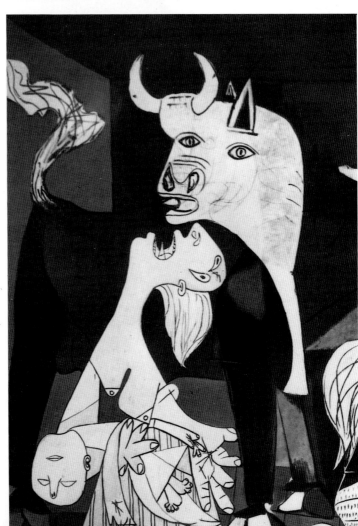

Detail of *Guernica*

Perhaps it would be useful to look closely at an example of nonrepresentational work at this point. We have now lived with the paintings that made Jackson Pollock infamous for the better part of fifty years, yet they still enrage new viewers. While revered by the elite, they elicit responses from others more likely to suggest that such art is the epitome of sham. Their most obvious problem is technique. Pollock's paintings apparently require no manual skill, no refined vision. Children accomplish as much with finger paints. Are these accusations just, or are they in fact part of Pollock's genius—his awareness that speed, spills, and the appearance of chaos are going to profoundly offend the sensibilities of many?

Since this chapter is dealing with ideas in art, we are going to dismiss the technical issues quickly by suggesting that anyone who thinks it is easy to create the interlocking layers of lines we see in a Pollock should try it and/or should give a child a chance. Don't forget that the painting reproduced here, entitled *One (Number 31, 1950)*, is almost nine feet high and seventeen feet wide. How much paint and how thick does it need to be to create an arc extending two or three feet? How indeed do you do it? How do you lay one set of lines on top of another, establishing a mass without losing the identity of each element, and yet allowing the canvas to show through all along? What colors do you choose to create a background that supports the individuality of each addition while giving particular emphasis to only a few? What goes on top of what? How long does all of this take, given the need for paint to dry?

If we consider these questions, or try to duplicate the technique, we find that instead of exhibiting the traditional skills of painters, Pollock replaces them with a different yet very thorough knowledge of the properties of paint, and also with the skills and

patience of an athlete, one who knows how to control a thrust (how much strength, how directed, and with what tool) that would send a tennis or golf ball to precisely where one wants it to go. So, if pitching a baseball is easy for you, you could one day learn to imitate Pollock's craft.

That said, let us see what is implied by this challenging, yet ultimately convincing, method. Calling forth no particular image to set parameters, Pollock steers clear of specific references, opening the field to greater numbers of associations and feelings. A fairly quick look at this enormous painting reveals that it is a field of black-and-white lines set against a beige background. While the background occasionally peeks through openings in the network of lines, it is most apparent in the margins of the painting, creating a kind of atmosphere that hovers at the edges of the central activity. This framing is penetrated by lines, drips, and blotches of paint pushing into its domain, especially at the bottom, and in some cases even seeming to extend beyond it.

Looking at this could be compared to looking at the Milky Way galaxy, where there is a concentration of celestial entities that do not really stop at defined borders but dwindle and carry on, perhaps infinitely. In this painting we can assume that we are seeing a concentrated form of energy, if only a slice of it. It carries on beyond the world of this canvas in imaginable, but perhaps wholly different, forms.

The paint is applied in lines that sweep, curve, encircle, link, or halt. Some fall, others climb in ways gentle or precipitous. Some are stable. They create edges and edginess. They intertwine and establish a network. They are isolated entities as well as integral parts of the whole.

Given the hegemony of black and white against beige, it takes more careful looking to see the gunmetal grays and neutral khaki browns that seem

to be used in amounts equal to the focal colors but, because of their relative tonal quietness, that act like bit players resonating and echoing the actions of the stars. Try to imagine the painting without the grays and browns. The contrasts would then seem very stark indeed, and less complicated, and in a way less intelligent in the metaphysical sense that we understand "gray" to suggest the area of compromise between opposing forces. Visually, black and white almost seem to cast gray and brown shadows that allow us to read depth and volume in what otherwise might be very flat planes. As we can see by comparing *One* to another Pollock painting, *Echo,* the additional colors contribute complexity, intrigue, and depth, both literally and figuratively.

Let us think for a moment about the symbolic qualities we associate with the chosen colors. In our culture, black is often associated with night, darkness, mystery, power, even evil. White calls to mind light, clarity, purity. They are seen as opposites and also describe opposing positions. "Black-and-white" refers to a film and photographic medium, one noted above as triggering associations with reality, plain and truthful. In painting, black is usually used to create shadows, shading, and darkening of tonal values, and white in an opposite but complementary way to allude to light sources, highlights, and lightening of tones. While they are not necessarily the boldest colors (compare them to a strong red or bright green), they are considered the starkest, together creating the best defined contrasts.

Gray, on the other hand, is often seen to describe all the middle ground, the middle of the road, the hardly apparent, the drab, the lifeless. Gray sets off other colors. It is seen as murky without being either good or bad, right or wrong. It is regarded as noncommittal, dull.

Brown is often considered the color of earth and therefore imbued with some warmth. Usually it is more comforting than assertive. It can connote ugliness or dirt, even filth, but it is more often associated with pleasant, natural phenomena.

We bring these associations with us to the activity of looking at pictures. Getting into the painting simply involves calling them forward into consciousness and then deciphering which of the possible associations works best in relation to the particular image.

In terms of composition, Pollock creates few points of concentration; however, even more so than in *Guernica,* we are not told what to look at, and we can follow our eyes as they dart from a flicker of light to a mass of darkness. To what is this darting analogous? A creative mind flitting from one thought to another? An unmitigated stream of consciousness? A world full of ideas, activities, and opportunities, each begging for and perhaps deserving attention? A wave of new possibilities and change that does not seem to cease, offering both bright spots and challenges? A frightening web capable of entrapping us?

Jackson Pollock's technique has come to be called "Action Painting," which is an apt term since by way of the paint you can track the actions undertaken to make the painting. The paint indeed conveys the energy with which it was applied, and, given that record and the natural property of lines to express meaning, Pollock opens up a universe of ideas to be mined, giving us a great deal of room to draw our own conclusions. We need to know nothing at all about his life, although if we pay attention to the painting's caption, we know that he is an American artist born in 1912 who painted this work in 1950. Our own memories and associations allow us to concoct a sense of context, of post–World War II America—a boundless, heroic, and victorious feeling of exuberance and power, tinged perhaps by

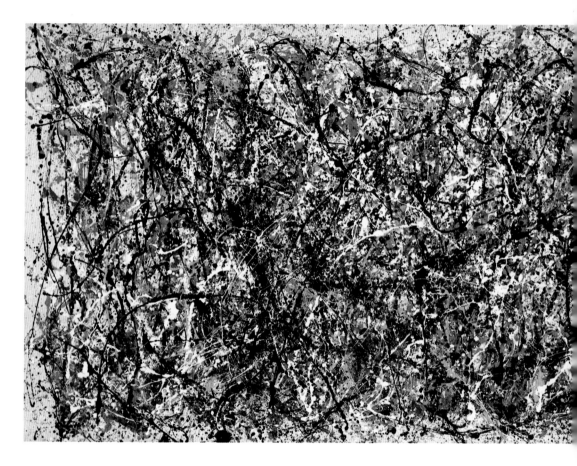

JACKSON POLLOCK (American, 1912–1956)
One (Number 31, 1950). 1950
Oil and enamel on unprimed canvas, 8′10″ × 17′5⅝″
 (269.5 × 530.8 cm)
Collection, The Museum of Modern Art, New York.
 Sidney and Harriet Janis Collection Fund (by
 exchange)

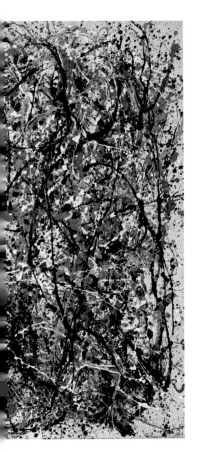

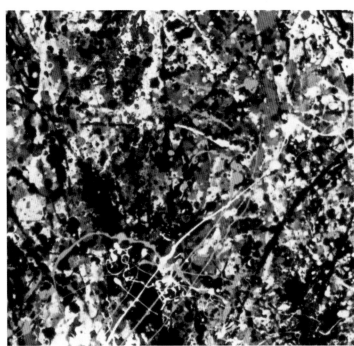

Detail of *One (Number 31, 1950)*

JACKSON POLLOCK (American, 1912–1956)
Echo (Number 25, 1951). 1951
Enamel on unprimed canvas, 91⅞ × 86″
 (233.4 × 218.4 cm)
Collection, The Museum of Modern Art, New York.
 Acquired through the Lillie P. Bliss Bequest and
 The Mr. and Mrs. David Rockefeller Fund

Pollock titled his paintings only after he had a chance
to step back and consider their effect. He chose to call
this relatively simple painting *Echo,* perhaps a
reference to the way so many of the lines seem to
have a partner, a second or third line following the
same pattern or rhythm. In *Echo* individual gestures
are easier to read, shapes easier to distinguish than in
One. But *Echo* lacks the weblike delicacy of *One,* as
well as its intensity, going instead for power and
clarity. Improvisational, like jazz, *Echo* seems to have
a heavy bass line against which the other instrumental
sounds appear to provide ornamentation.

hubris, as well as some fear of what superpower
responsibility might mean. The United States was
overtly hostile to the Communist threat and aware of
Hitler and his heinous abuses of power. We felt a
dawning awareness of the implications of Freudian
analysis and at the same time maintained
segregation and put limitations on the roles of
women. There lingered a post-Depression sense of the
unreliability of money. And so forth. What are your
own associations with 1950?

When we think of this world, is not the edgy
energy of Pollock's paintings an appropriately
complex metaphor for this consciousness? Think of
its symbolic possibilities in the face of these issues.
How do you think Pollock felt about the world
around him? Was he optimistic or pessimistic? Why
do you think that?

Eleven years after Pollock painted *One,* Jasper
Johns created *Map,* a painting that combined a kind
of representation, that is, a map of the United States,
with many issues more common to abstract painting.
Johns visually articulated an intense discussion about
painting, arguing the virtues, demerits, and always
the pleasure provided by combining representation
with conspicuous color, lines, and readable gestures
(brushstrokes), as well as letting paint speak for itself
on flat canvas surfaces.

Map is a large painting that uses a limited
number of bright colors—the primary colors of
blue, red, and yellow, from which all other colors
are mixed. We can also find traces of white,
sometimes covering up what is below, sometimes
blending with colors beneath it. We find black, as
well, used to emphasize a line or mixed with
existing tones to get darker or muddier ones.
Although the selection of colors is limited, both the
choice of hues and way the paint is applied

discourage us from comparing *Map* to the drab appearance and the relatively meticulous brushwork of *Guernica,* or with the frenetic linearity of *One.*

Like Picasso, Johns has chosen to paint a recognizable subject, but in this case it is a neutral one. His powerful color choices and the aggressive, messy way he painted it are what enliven the painting, unpredictably. If we begin to look carefully at how Johns has rendered individual states—check out ones with which you have some personal affinity—we can legitimately wonder if he is not expressing some kind of viewpoint. Why, for example, is Virginia washed out with white, extending even over Washington, D.C.? Why is California half-covered with the blue of the Pacific Ocean?

A look at the caption tells us this was painted in 1961, which was the year John F. Kennedy took office, following the generally tranquil and prosperous Eisenhower 1950s. The civil-rights movement was just beginning, with attacks on the Freedom Riders awakening many to the realities of segregation. The Peace Corps was being formed, the Berlin Wall had been built, and there were confrontations with Khrushchev and Cuba, including the Bay of Pigs debacle. The Twist was the rage, *West Side Story* took Broadway by storm, and the United States put its first person in space. Were we beginning to take a new look at our country? A look that called for representing it differently?

Whether or not we try to interpret this painting as a rethinking of America, we discover maps to be an interesting visual subject because while they are themselves concrete objects, at the same time they are abstract representations of geographical and political boundaries, somewhat arbitrary organizations imposed on the land. A subtle but important conceptual issue arises here: Has Johns painted a map, or a painting of a map? We might think both, but he felt it was the former, that instead of trying simply to represent something, as most past painters have done, he painted the thing itself. Theoretically, we could use this map in a classroom as easily as another.

Johns may have chosen to paint a map because it is so familiar. We find it neither threatening nor precious, and thus we can accept it with none of the distance we might associate with paintings; we might even be attracted to it. The map's very ordinariness is stressed by the stenciled letters that matter-of-factly label each state. The generic quality of both map and letters (What classroom is without either a pull-down map or a set of stencils, often in these very letter forms?) serves as a comfort mechanism. But, by utilizing them in a painting, Johns also suggests that maybe we should take another look at how we relate to and feel about ordinary things around us. We might come to appreciate them more. We might also decide the ones we have are boring, to be discarded and replaced by others more satisfying.

But maybe the ordinariness is a trap as well. Lulled by the map's familiarity and the stencil's generic quality, we might take some time before looking carefully enough to observe the many different ways Johns has found to apply paint, to see, for example, that Ontario has been painted with such watery paint as to drip into the Great Lakes. And gorgeously colorful New Mexico is a dishwater color, brushed rapidly with wet paint on top of other wet paint. If we stop to think about it, we might be shaken from accepting this supposedly innocent subject at face value.

The map provides not only the subject but also the structure of the painting. As noted earlier, a stable composition is an issue in most art. Look at

JASPER JOHNS (American, b. 1930)
Map. 1961
Oil on canvas, 6′6″ × 10′3⅛″ (198.2 × 314.7 cm)
Collection, The Museum of Modern Art, New York. Gift
 of Mr. and Mrs. Robert C. Scull

Detail of *Map*

Detail of *Map*

Guernica, diagram of composition

The division of a painting into three parts—a triptych
with one central and two smaller side panels—is
traditional, particularly in paintings that contain some
form of narrative having several vignettes. Picasso
divided his story of Guernica into three integrated
parts, the two side events being somewhat easier to
decipher than the central one, where a jumble of
bodies (including a disjointed horse) seems to be
unified by a large triangle overlaid by a smaller
diamond shape, a sort of eye of the hurricane. The
left panel seems to have two diagonal thrusts upward
and inward, culminating with focused intensity in the
bull's face. The arms of the man on the right create
two shafts of an upended triangle, which tends to
amplify his scream as if through a megaphone.

Map, diagram of composition

In addition to using the near-grid supplied by the outline of states, Johns divides his canvas into three vertical sections, probably as an academic reference to this frequent convention in painting. It also serves the purpose of structuring this large work into stable, readable units of which we might not be aware until we look closely. Johns has also created a gently curving horizontal line across the middle, perhaps wanting to call to mind the horizon line typical of a landscape painting, which, in a way, this map is.

Guernica again to see a powerful triangular form in its center, flanked by virtual columns, all created by lines of color and gesture. For *Map,* the blocking out of states and provinces provides a grid that divides the painting into readable units. Lines between states, often emphasized either by black or by strongly contrasting colors in neighboring states, divide the whole canvas vertically into three almost equal, slightly rounded sections. Certain state lines are also emphasized to cut the painting horizontally, perhaps creating a horizon for this landscape. The resulting subdivisions combine logically to create a stable whole, which allows anarchic brushwork and a seemingly random, off-balance arrangement of colors to exist without threatening the overall unity of the work.

A surprising degree of pleasure comes from examining the work for visual minutiae, from musing on such fine points as why Michigan and Pennsylvania are abbreviated and why some other state names are spelled out in large letters and others in small. The subject and structure, seemingly rigid and perhaps even uninteresting, limit Johns to narrow parameters within which he may test his imagination. Just as any map represents an enormous geographic, political, and social complex, just as it uses lines and place names to render comprehensible a variety of people and places — countryside and town, water and mountain — Johns brings up the many sides of representation, from diagrams to words to the painted language of lines, color, texture, and gesture. By acting within a tight framework, he opens the door to a vast nexus of visual possibilities, as well as ideas.

We have during the last discussion looked at three works that use different means to convey ideas. Given a theory projecting a linear progression of painting from Cézanne to the present, one could

view Picasso as the great experimenter with representational painting, Jackson Pollock as the apotheosis of abstraction, and Jasper Johns as the philosopher who established the dialogue between the two. Picasso dropped out color and realistic detail and eliminated place and personality in order to depict the general horror of war. Pollock removed any reference to the world in order to encapsulate less distinct experience, leaving room for a variety of interpretations to emerge. Johns chose a neutral, familiar subject to allow himself room to investigate all sorts of issues having to do with paint and painting and, in fact, with the nature of images as representation of things, an investigation that recalls Cézanne.

In choosing to eliminate various kinds of available references and illusionary techniques, these artists might at first glance seem to have limited possible responses; in fact, their reduction of information opens up possibilities. In so doing, they indeed increase the scope of the viewers' job. Although Johns uses an intentionally common visual subject in order to reduce the kind of subjective interpretation that Pollock seems to beg for, his intentions do not limit our imagination. He may have intended no puns and no editorial comments, and he will claim none, but that does not stop us from finding them. Artists often achieve things they do not intend and do not always succeed in communicating things they do. This phenomenon, this "fallacy of intention," as it is known, is itself justification for us to assume responsibility for finding meanings that seem right to us.

This process takes us further into the fighting arena of the "retinal versus the ideological." Rich visual works such as those we have been examining contain and convey impressions and ideas that seem to operate on several levels. They are quite different

from ones in which the visual cues are relatively few and where most of the aesthetic experience comes from engaging scant data in a process of thought. In this latter circumstance, various ideas build on others, and the nature of the experience is more purely conceptual.

To illustrate this point, I would like to look at a series of works that might be called "landmarks of experience," richly fruitful stimulants of creative thinking rather than objects of particular consequence in themselves. One such series is by Sherrie Levine, who in the early 1980s made small photographs and watercolors, unpretentious and unprepossessing, which have an alarming quality of déjà vu. Where have I seen these before? one asks, and a glance at the titles helps to suggest where. They are called *"Untitled" (After . . .);* Levine fills in the blanks with various artists' names: Walker Evans, Arthur Dove, Piet Mondrian, Fernand Léger, Willem de Kooning, Alexander Rodchenko, and so on. The "Levines" are in fact copies of works by other artists.

Strictly speaking, the copies are not replicas because they are invariably changed in scale and usually in medium—from oil, for example, to watercolor—but they are copies, nonetheless. What Levine ironically tries to reproduce, however, is the quality of (and mistakes inherent in) book illustrations, not the originals. Despite this emphasis on reproduction, the works, nevertheless, closely resemble the originals and therefore provide much the same information and aesthetic value. Most of what we appreciate in a real Mondrian is there in Levine's version, to be appreciated again.

The first question raised by these works is likely to be about originality and the relationship of originality to creativity. Artists such as Meret Oppenheim, Marcel Duchamp, and Andy Warhol,

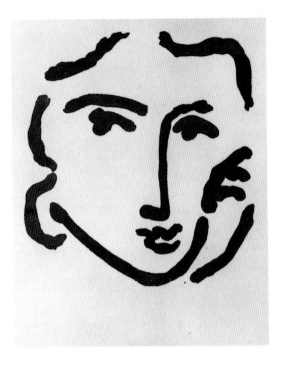

SHERRIE LEVINE (American, b. 1947)
"Untitled" (After Henri Matisse). 1985
Watercolor on paper, 14 × 11″ (35.6 × 27.9 cm)
Courtesy of Mary Boone Gallery

whom we discussed earlier, already asserted that originality and creativity exist in ideas and actions, not things. They declared that a "readymade" could be art, that the craft of an artist was inessential, and that the object itself was unimportant. The one logical step in following this line of reasoning is to wonder whether or not an art object need exist at all, which delivers us to the footings of Conceptual art. Another is to say that if readymades can be used by artists, it is equally acceptable to appropriate existing artwork as it is to subsume a teacup. Such appropriations might intend to be absurd, but they also might be an attempt to restate the aesthetics of something, seeing them in a different light — as it is in Levine's case. Originality, to Levine, has to do with raising an issue, not with inventing an image.

This attitude assumes that originality is impossible, anyway, given that there is nothing new under the sun. Therefore, invention and uniqueness are no longer essential in making art. Originality might, in these terms, be an egoistic grasping for individual recognition in a world that is ever more needful of the opposite — cooperation and integration. This theory also acknowledges that the notion of originality actually runs counter to most traditions in art. Most cultures through time, in fact, have felt no need to identify artists personally, even if they were especially gifted. Individual achievement was not prized over tradition, consensual agreement, and group interaction.

Meanwhile, however, if copying someone else's artistic production seems reprehensible and too easy, how about the way we pick up and repeat verbal information, opinions, and facts we find pertinent? In conversation, we do this as a matter of course. How about retelling jokes we hear? There is a strong tradition among us to borrow and quote when we find someone has already made our point or said it better than we could. We quote love lines from Shakespeare because they are perfect. Sherrie Levine does somewhat the same thing, always crediting her source, as literary precedents decree, which we as individuals may or may not do.

Levine's titles do more than credit her source, however. The term "after . . ." can mean later than or following. It can mean inspired by, as in Johannes Brahms's *Variations on a Theme from*

SHERRIE LEVINE (American, b. 1947)
"Untitled" (After Walker Evans: 7). 1981
Black-and-white photograph, $10 \times 8''$ (25.4×20.3 cm)
Courtesy of Mary Boone Gallery

This image, five or six generations of printing away from its original negative, exaggerates the by-products of reproduction: intensified whites and blacks and loss of subtle gradations from light to dark. We can look at this as distortion, but we can also examine it for the things gained. The most basic gain is access: this particular image might otherwise be unknown to us. Another is its quality of pathos: because it is lacking in formal photographic qualities, this photograph may encourage concentration on its subject. Sherrie Levine rephotographed this image, originally taken by Walker Evans as he toured the United States documenting the Depression. While collecting evidence of poverty in America, Evans always gave great attention to compositional issues and to the qualities listed above that are diminished in Levine's reproduction. By reducing the formal perfection, we have left, then, something that is more a document of what Evans started with, perhaps made more touching because of the heavy contrasts of black and white, the general dirtiness of the image itself. While we might be satisfied to see Evans's original image as a still life, here we are urged to wonder about the life of the person who sits in this chair.

Haydn, as well as influenced by, in the way that Johns might have been freed of technically perfect painting because Pollock had already legitimized abandonment of rigid rules. It can mean copying an aspect of some preexisting thing, such as the style or subject of an earlier artist, or simply building on earlier discoveries. It can also mean all of these things and can furthermore imply that once something is made and is out in the world, all that happens is affected by its presence just as the course of events affects the way we see it and how we think about it. This latter issue is what seems of prime concern to Levine.

Part of how we see and know things relates to the role of reproductions in art today. An artist makes something and we the public see the work, either exhibited in museums or galleries or, most often, by way of reproductions in books or magazines. Many of us grow up with reproductions that we come to know, love, even possess, most often never having seen the original. Some people do not make the distinction between the reproduction and the original. Some do not know there is one to be made. Quite clearly, most of what we know of art is known by way of reproductions, even among art historians poring over books and slides.

Most of us, therefore, know better than to accept a position that says we know nothing of Gothic architecture unless we have toured Chartres Cathedral. We recognize the insight and under-standing—also the pleasure—that seeing the original brings, but we will not let anyone tell us we can not gain enjoyment and learning from books, slides, films, and such—nor from listening to recorded music and watching television news reports of events from around the world. What Sherrie Levine explores is the nature of this secondhand experience. In imitating scale and color as seen in reproduction, she also elucidates their aesthetics.

Levine wants to remind us, however, that each circumstance in which we encounter a work is in fact a context, even our own bedroom postered with favorite reproductions, comfortable and familiar. We might find a photograph treated in one book as a work of art and in another as photojournalism. On one hand, it might be looked at as exemplary of the aesthetic of a period and, on another, as a generic illustration of a piece of fiction.

Each of these contexts shifts our consciousness of the photograph's meaning. It can become either more or less touching and it can inform in different ways, at one point illuminating a capacity of photographic technology or at another providing human interest. It can be an isolated entity or part of a narrative. It can be seen for its formal pictorial qualities or its inherent pathos. It can be a throwaway or made to seem precious. This very mutability is of major concern to Sherrie Levine. If Jasper Johns generalizes about the nature of representation, Levine likes to look at specific instances to see how subtle shifts in context change entire meanings.

For example, because Levine chooses most often to reproduce works by men, gender issues are an inevitability in her work, particularly when she takes on an artist such as Willem de Kooning, redrawing his gestural sketches of women. Some see the ugliness and grotesque sexuality of De Kooning's drawings as ambiguous, perhaps filled with fear, and likely misogynistic. When the identical drawings are appropriated by a woman, they actually expose just these possible readings. Yet, if Levine finds in herself things she fears or wants to render in grotesque terms, it is different from a man depicting the identical subjects. The author/artist of any statement defines the context in which the comment is seen.

SHERRIE LEVINE (American, b. 1947)
"Untitled" (After Arthur Dove). 1984
Pencil and watercolor on paper, 14 × 11″
 (35.6 × 27.9 cm)
Courtesy of Mary Boone Gallery

As works by many artists are recycled in similar
formats and scale, famous and influential artworks
become the equals of ones less well known or favorably
noticed. Here Levine copies a work by the
individualistic and innovative American abstract
painter Arthur Dove, who was overshadowed by his
European counterparts.

SHERRIE LEVINE (American, b. 1947)
"Untitled" (After Willem de Kooning). 1981
Charcoal on paper, 14 × 11″ (35.6 × 27.9 cm)
Courtesy of Simon Watson, New York City

The gender of the person who calls something ugly preconditions the nature of the call.

Sherrie Levine focuses on what shapes our knowledge and experience of art. Working like a magazine picture editor who chooses visuals to support text, she selects images that she has found in books, because that is how she, like the rest of us, knows them. When she creates *"Untitled" (After Arthur Dove)*, she has picked and chosen among the images that interest her most for subject or form — things that may or may not have been the obvious or stated concerns of the artist. It may be that her selection of an image by the American early modernist Arthur Dove was motivated by his relative obscurity. Dove was one of the first to paint completely nonobjective paintings, but because several European pioneers are better known, Dove never gets the attention he deserves.

Sherrie Levine is aware of the influence of the past, intrigued by its visions, and informed by its discussions. This has led her to work in ways that are highly theoretical, quite different from the political engagement of *Guernica,* the emotionalism of *One,* the visual and conceptual interplay of *Map.* With some of the irony of Warhol, she recycles a title such as "Untitled," poking fun at artists who use this modern convention, claiming that there is no meaning beyond what one sees, and/or who wish to give no verbal clues to support the viewer's interpretive activity. Appreciation of this little stab comes more from the pleasure of musing on Levine's use of quotation marks than from looking at an image.

Lest we leave this discussion with the impression that all art has proceeded to this degree of theoretical stance, however, we should take brief looks at two other artists who are equally concerned about how context shapes meaning and experience, and who are also deeply committed to an art that integrates the realities of modern communication in the way that Levine addresses the content of reproduction.

The first of these artists is Cindy Sherman, who has been working for more than a decade on series of self-portraits in various disguises and settings. Through the variety thus attainable, she makes a point of depicting how women in general have been portrayed, first in film, television, and popular photography, and then working her way back to traditions in painting and nonvisual mediums, such as opera and fairy tales. In the same way that both Johns and Levine work in reference to other aspects of visual-arts tradition, Sherman positions her work as a critique of various conventions of depicting women. But by using only herself as model, she also brings up the idea of each woman as a complex of many possibilities — at once or alternatively maternal, glamorous, demure, efficient, vulnerable, domineering, pure, wicked, and so forth — showing the individual woman as an intricate matrix as well as women in general as diverse in style and substance.

At different times, Sherman has used black-and-white and color photography, again to achieve different effects, and she has worked in a variety of scales, from small and deliberately ordinary to large, grand, and showy. The different examples here elucidate the range of her concerns. Sherman's simulated "film stills" — still images set to look as if they were part of a narrative — are in black-and-white, again emphasizing the medium's documentary role.

In addition to having the heightened character and lushness of Technicolor photography, her color images take on other traditional systems of representing women. In the case of the one presented,

Above and following page:

CINDY SHERMAN (American, b. 1954)
Six Untitled Film Stills. 1979
Black-and-white photographs, each 8 × 10″
　　(20.3 × 25.4 cm)
Courtesy of Metro Pictures

Using wigs, costumes, and a variety of settings, Cindy Sherman creates self-portraits, all theoretically still images from movies, that give a hundred faces to women. Whether she is pushing a stereotype, exploring a dark view, or depicting vulnerability, Sherman's sympathy for women—especially exploited ones—is clear. Deliberately ordinary and unpretentious, even banal, Sherman's aesthetic choices underscore the lack of value ascribed to most traditionally "feminine" roles by our social structure.

Sherman has emphasized the more vulgar possibilities inherent in portraiture designed to show off the wealth and material status of the sitter.

In all cases, the images count on details of costume, setting, gesture, and expression to establish the context. In general, they relate to Pop Art's use of imagery and techniques familiar within popular culture to present a careful look at the subtexts and assumptions of any system of representation.

The focus of Jenny Holzer's art is text: short sequences of words that range from slogans ("truisms"—statements that seem to have the ring of truth—or comments on survival) to longer statements that are distinctly poetic in the way they create images and evoke responses without narrative references or regard for logical meaning. The visual aspect of her work varies from printed broadsides, brass wall plaques, and shirts and hats to electronic signboards and inscribed stones. Each of these methods of presentation has its own "normal" context, none of them artistic, which allows for presentation of art in widely different and often completely surprising circumstances. The work thus reaches audiences outside the normal confines of the art world, disrupting very real-life contexts by activating them with wholly unpredictable information—information of a sort that almost inevitably produces a double take, an act of conscious recognition. Absorbed in an activity—such as walking down the street—and confronted by the statement "ABUSE OF POWER COMES AS NO SURPRISE," one is very likely to awaken abruptly from whatever preoccupation.

Aside from introducing whole new arenas for art activity—streets, ballparks, office buildings—Holzer's work draws, like Sherman's, on pop-culture technology, ultimately exploring the beauty or at least the visual expansiveness possible in electronic

CINDY SHERMAN (American, b. 1954)
Untitled (204). 1989
Color photograph, 67¾ × 51¼" (172 × 130 cm)
Courtesy of Metro Pictures

Imitating the conventions of painted portraits of the eighteenth and nineteenth centuries, Sherman photographs herself in the trappings of wealth while allowing a certain baseness and slovenliness to show through the signs of affluence. This image is overlarge and visually arresting, as if to mimic grandness while eluding greatness.

signage, for example. Perhaps more significant, Holzer acknowledges that today's communication systems allow us to hear multiple viewpoints on any issue and to witness different sets of emphases. An AM radio broadcaster will likely report on an event differently from an "educational commentator." *The New York Times* chooses different stories to headline from those of *The National Enquirer.* Holzer's sequences of comments also come from different, even opposing, points of view, one way of acknowledging the dichotomy—the yin and yang—possible within all things.

A sequence such as "CHILDREN ARE THE CRUELEST OF ALL" followed by "CHILDREN ARE THE HOPE OF THE FUTURE" illustrates the point. Although contradictory and only half true, they are both paradoxically more accurate than not. "EXPIRING FOR LOVE IS BEAUTIFUL BUT STUPID"; "PRIVATE PROPERTY CREATED CRIME"; and "WHAT URGE WILL SAVE US NOW THAT SEX WON'T?" further illustrate the range of comments from funny or ironic to polemical or obscure. Each truism requires a different response, puts us in a new place, subverts expectations, and diminishes the dependability that traditional art ensures and that we also expect from news and advertising, despite knowing that each often misrepresents, abbreviates, and contradicts itself.

Just as Sherman addresses the complexity involved in depicting women, Holzer dramatizes the paradoxical multiplicity of viewpoints that intersect and to some extent battle within our culture. While Sherrie Levine is intrigued by the art world and the rubrics of art, Holzer takes on the masses, mixing poetry and aesthetics with politics and consumerism to reach out in a way that speaks to and affects daily experience. She personalizes normally impersonal media, using a public forum in order to bare her soul, as illustrated in her LAMENT inscribed on a stone bench, which probably addresses AIDS. Holzer treats public media as stages for something profound. She moves in a way comparable to Johns in his use of the innocuous map as an arena for examining a huge variety of visual communication techniques. In so doing, Holzer encroaches on the media's presumed objectivity and undermines their authority.

Some cultures have had nothing they specifically called art; nonetheless, they produced brilliant representations, impeccably crafted objects that were deeply embedded in their respective cultures. Holzer respects this kind of tradition and examines the possibilities of creating art in a fashion that seamlessly integrates the artistic experience into the culture at large.

JENNY HOLZER (American, b. 1950)
Selection from THE SURVIVAL SERIES. 1986
Spectracolor Board. Installation, Times Square, New York City
Courtesy of Barbara Gladstone Gallery, New York

A SINGLE EVENT CAN HAVE INFINITELY MANY INTERPRETATIONS
BAD INTENTIONS CAN YIELD GOOD RESULTS
CRIME AGAINST PROPERTY IS RELATIVELY UNIMPORTANT
DEVIANTS ARE SACRIFICED TO INCREASE GROUP SOLIDARITY
FAITHFULNESS IS A SOCIAL NOT A BIOLOGICAL LAW
GOVERNMENT IS A BURDEN ON THE PEOPLE
ILLNESS IS A STATE OF MIND
IT IS MAN'S FATE TO OUTSMART HIMSELF
IT'S BETTER TO BE LONELY THAN TO BE WITH INFERIOR PEOPLE
KILLING IS UNAVOIDABLE BUT IS NOTHING TO BE PROUD OF
LABOR IS A LIFE-DESTROYING ACTIVITY
MANUAL LABOR CAN BE REFRESHING AND WHOLESOME
MONEY CREATES TASTE
MOTHERS SHOULDN'T MAKE TOO MANY SACRIFICES
NOTHING UPSETS THE BALANCE OF GOOD AND EVIL
OCCASIONALLY PRINCIPLES ARE MORE VALUABLE THAN PEOPLE
PEOPLE WHO DON'T WORK WITH THEIR HANDS ARE PARASITES
PEOPLE WON'T BEHAVE IF THEY HAVE NOTHING TO LOSE
PRIVATE PROPERTY CREATED CRIME
RELIGION CAUSES AS MANY PROBLEMS AS IT SOLVES
ROMANTIC LOVE WAS INVENTED TO MANIPULATE WOMEN
SALVATION CAN'T BE BOUGHT AND SOLD
SELFISHNESS IS THE MOST BASIC MOTIVATION
SELFLESSNESS IS THE HIGHEST ACHIEVEMENT
SLIPPING INTO MADNESS IS GOOD FOR THE SAKE OF COMPARISON
STUPID PEOPLE SHOULDN'T BREED
TALKING IS USED TO HIDE ONE'S INABILITY TO ACT
THE FAMILY IS LIVING ON BORROWED TIME
THE MORE YOU KNOW THE BETTER OFF YOU ARE
THE NEW IS NOTHING BUT A RESTATEMENT OF THE OLD
THE SUM OF YOUR ACTIONS DETERMINES WHAT YOU ARE
THINKING TOO MUCH CAN ONLY CAUSE PROBLEMS
USING FORCE TO STOP FORCE IS ABSURD
YOU HAVE TO HURT OTHERS TO BE EXTRAORDINARY
YOU NEVER KNOW WHAT PEOPLE REALLY THINK ABOUT YOU
YOU OWE THE WORLD NOT THE OTHER WAY AROUND
YOU SHOULD STUDY AS MUCH AS POSSIBLE
YOUR ACTIONS ARE POINTLESS IF NO ONE NOTICES

JENNY HOLZER (American, b. 1950)
Selections from TRUISMS. 1977–79
Courtesy of Barbara Gladstone Gallery,
New York

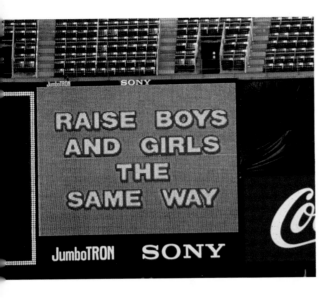

JENNY HOLZER (American, b. 1950)
Selection from TRUISMS. 1987
Installation, Candlestick Park, San Francisco
Courtesy of Barbara Gladstone Gallery, New York

The content of Holzer's "truisms," appearing randomly among the sequence of advertisements and/or baseball statistics, inserts unpredictable thoughts, inappropriate for the setting yet all the more meaningful for interrupting. For Holzer, who also gives great attention to the motion and color that can be programmed for these signs, it is important to get people to think, to question their assumptions and examine their feelings. Her art depends on the efficacy of the surprise attack.

JENNY HOLZER (American, b. 1950)
LAMENT. 1989
Black granite, 82 × 30 × 24⅜″ (208 × 76.2 × 61.9 cm)
Courtesy of Barbara Gladstone Gallery, New York

Using language to conjure images and sculptural contexts to draw attention to poetry, Holzer continues to find new ways of presenting comments full of conflict, paradox, roughness, and caring. These laments seem to come from an identifiable voice, although it is not necessarily always Holzer's own. The flow of her writing is both speedy and jumpy, but unlike "stream of consciousness," the meaning of each sentence is clear. You can discern what each precise line is saying, however angry, rude, or poignant. It is likely that the subject of this poem is AIDS, and her comments range from descriptive of the phenomenon to emotionally responsive. She is both inside her own feelings and reaching out, expectantly.

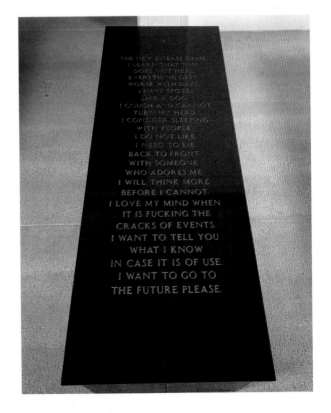

ANALYZING, INTERPRETING, AND JUDGING

BARBARA KRUGER (American, b. 1945)
Untitled (Your Gaze Hits the Side of My Face). 1981
Photograph, 55 × 41″ (139.7 × 104.1 cm)
Collection Vijak Mahdavi and Bernardo Nadal-Ginard,
 Boston, Mass.

Barbara Kruger combines black-and-white photographic images with texts arranged to remind us of certain kinds of magazine layouts. Even though her words and images have precise meanings when observed as isolated elements, taken together they have implications beyond the obvious. This image is cryptic because one seldom thinks of a gaze as having the power to "hit"; the verbal message here is sobering if one observes the gaze directed toward the young woman's profiled face. The act of staring is seen by Kruger as transgressive, even violent.

The point of the previous chapter is to illustrate the ways in which visual data can inspire an array of ideas. By observing and analyzing various visual aspects of artworks, one finds a whole range of associations and interpretations is possible, and these in turn release the imagination into a realm of creative thought. Modern art, in its vast diversity, is particularly geared toward triggering this kind of active response on the viewer's part.

Analysis is a process of seeing how our various observations interact with and influence one another. While looking at a work, we may first want to isolate elements; analysis pieces them back together. Part of this piecing involves thinking about the artwork in terms of external contexts, trying to recall, for example, events in the world that may have influenced it. Another very critical part of this requires sorting out one's own, more personal sets of references and associations with subjects, moods, colors. Also, comparing a work to others sometimes helps to clarify its content and meaning.

One thing to keep in mind is that analyzing works can be a captivating experience in itself. Much like reading good literature and seeing films—where we get caught up in good stories, snappy dialogue, strong images, odd characterization, humor, suspense, and so forth—looking at art can be a process that engages our senses, memories, and intelligence in such a way that we enjoy the experience regardless of whether or not we delve into speculation about an artwork's meanings.

That fact notwithstanding, the real meat of the visual experience comes from seeking symbols and relationships, making analogies and metaphors, and finding ideas and implications that emerge from the given observations. Moreover, these are the activities that are ultimately most useful to us, particularly in

a time when most experiences ask too little. Such critical thinking is the most useful tool we have for negotiating our complicated, ever-changing world.

When studying works in reproduction, we have to downplay such issues as size and surface texture, except inasmuch as we can imagine them. Taking a look at caption copy for dimensions and then trying to visualize size is, therefore, a useful exercise. So, of course, is thinking about how titles, national origins, and dates contribute to our thinking. Titles give a clue as to what the artist intends with a work. Even "untitled" is a directive: the artist apparently does not intend for us to have a verbal handle to guide our thinking; we are told to go it alone. Dates and locales of birth and death and of when a painting was done give us clues, maybe the best ones we will get, for thinking about the world in which the artist works. We have already seen how this information can be helpful in thinking through subject matter and, to some extent, the artist's intentions.

ANSELM KIEFER (German, b. 1945)
The Red Sea. 1984–85
Oil, lead, woodcut, photograph, and shellac on canvas,
 9′1¾″ × 13′11⅜″ (278.8 × 425.1 cm)
Collection, The Museum of Modern Art, New York.
 Enid A. Haupt Fund

In a Red Sea turned mostly a murky brown-black, Anselm Kiefer's apparent boat seems more like a coffin. Kiefer grew up in Germany after World War II, and this painting of the mid-1980s depicts a postapocalyptic environment, with chards of both man-made and natural objects strewn around it. He titled the painting after the body of water that first separated the Jews, exiled to Egypt, from their homeland but which then parted to allow them to escape slavery. As a symbol, therefore, it is potent; it reminds us of the Jews during the Nazi era for whom the sea did not part.

Because this book focuses on what can be learned from looking and thinking about works, there are few historical or biographical facts inserted to augment what we can recall on our own. But because such data are valuable in the long run, there is a minimal bibliography at the end of this book, consisting mostly of art-historical surveys or books on single artists. Art history can provide insight into the way art was seen in another time as well as how it is viewed from a more distant perspective.

Biographies can supply the personal context of an artist. In addition, there are social, political, and religious histories as well as anthropology studies to be referred to; these are relevant because they give insight into the broad fabric of society. While these sources are deemphasized here, there is no reason to ignore factual data and what other people think, particularly once you have established that a subject or artist interests you.

Because of the way context enhances meaning, it is useful to look at the setting in which you encounter an art object. Just as you may know people very well at work, you find altogether different information about them when you meet them at a ball game, party, or with their family. So it is with art, as was discussed in relation to Sherrie Levine. If you happen across a painting in a friend's house, you will see it differently from the way you might in a museum or gallery.

Inevitably, as you look, elements of style will begin to sort themselves out for you. Some stylistic characteristics have been introduced in this text. For example, in discussing *Guernica* we noted certain characteristics of the Cubist style: flattened spaces, simplified shapes, limited color range, fragmented composition, and so on. Elsewhere, I mentioned that Expressionism typically emphasizes strong colors and lines and that one can usually trace the record of the artist's gesture in such factors as brushstrokes. By recognizing stylistic hallmarks, you often have immediate entry into an aspect of the artistic context in which an artist is working, although you still have to delve into the particulars to find what any artist has to say as an individual. Noting elements of style can be a kind of shortcut to meaning, useful as such, as long as we are conscious of its limits. With notable exceptions, such as the Futurists, who conscientiously grouped themselves around a theory, the critics are the ones who usually identify and name stylistic trends, often out of derision and misunderstanding, and artists resent the pigeonholing. So, remember that, despite their usefulness—and I have devoted the "Useful Vocabulary" chapter of this book to brief definitions of various styles—styles are only a key, not a door. Exceptions to every stylistic generality abound, and therein lies much meat for productive analysis.

Ultimately, one makes a judgment about whether or not a work is "good." This might be an attempt to align its merit with some objective standard of aesthetic value but might equally well be a subjective opinion. The matter of aesthetic quality is not simple. At any given moment, there may be a consensus among curators, artists, critics, dealers, and collectors that theoretically determines artistic merit, but a look at history also shows that some things greatly admired later were scorned when first introduced, and vice versa. One week graffiti is a nuisance, the next week it is the artistic rage. In one context it is scribbling on walls and can get you arrested, and in another it can make you rich. Regardless of momentary celebrity, some artistic rages do not sustain the test of time.

In the past, cultural groups as a whole determined what their "art" was, even when it did

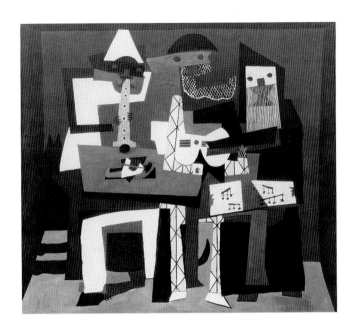

PABLO PICASSO (French, b. Spain, 1881–1973)
Three Musicians. 1921
Oil on canvas, 79 × 87¾″ (200.7 × 222.9 cm)
Collection, The Museum of Modern Art, New
 York. Mrs. Simon Guggenheim Fund

Painted in the angular, flat style of Cubism, with
its intentionally confusing space and broken-up
shapes, this 1921 Picasso image seems to contain
other, less formal, more expressive concerns than
most Cubist paintings. The addition of costumes
and masks gives this odd trio of two classic
clowns and a monk a sense of mystery. There
may be a story here, an unusual inclusion in
Cubist art.

PABLO PICASSO (French, b. Spain, 1881–1973)
Three Women at the Spring. 1921
Oil on canvas, 80¼ × 68½″ (203.9 × 174 cm)
Collection, The Museum of Modern Art, New York. Gift
 of Mr. and Mrs. Allan D. Emil

This classical painting of three very round, even fleshy,
women bathed in a strong light, set off against a
background of rock, is a very different kind of picture
from the *Three Musicians,* although Picasso painted
them in the same year. Despite the imprecise and
somewhat ambiguous nature of the setting, Picasso's
concern for using traditional notions of picture-making
is here as "modern" an idea as abandoning all the
rules. This painting implies a different way of seeing
from the *Three Musicians,* and Picasso's willingness to
work simultaneously in varying modes is an example
of his boldness.

ERIC FISCHL (American, b. 1948)
Portrait of a Dog. 1987
Oil on canvas in 4 parts, 9'5" × 14'2¾" (287 × 433.7
 cm) overall
Collection, The Museum of Modern Art, New York. Gift
 of Louis and Bessie Adler Foundation, Inc.,
 Seymour M. Klein; President; Agnes Gund;
 President's Fund Purchase (1987), Donald B.
 Marron, President; Jerry I. Speyer, The Douglas S.
 Cramer Foundation; Philip Johnson; Robert and
 Jane Meyeroff; Robert F. and Anna Marie Shapiro;
 Barbara Jakobson; Gerald S. Elliot; and purchase

Eric Fischl is called a "Neo-Expressionist" because of the powerful reaction provoked both by the way he paints—messily, aggressively—and by his choice of subjects. The latter often involves an invasion of privacy; here a naked woman kneels to wash her hair in a tub, unaware of being observed. Images are illogically juxtaposed; sharing the bathroom are a man dressed for a stroll in the country and his arching dog. The viewer, positioned behind a toothpaste tube on the right, is implicated as a voyeur, spying not only on the woman's toilette but also on the mask-faced man whose stance seems too awkward to be public; perhaps he is training his dog out of sight in a bathroom. The point of view is distorted. We seem to look in through a glass, which initiates a disjointed perspective echoed by shaped canvas, cut apart as if to create a collage of candid snapshots taken while the subjects were not looking. All of this seems calculated to reveal the nature of overheard conversations or glimpses of things not meant for our attention—our vague embarrassment, perhaps feelings hurt by possibly uninvited discoveries.